WINDⅅW | INTEᴦFACE

WINDOW | INTERFACE

Sabine Eckmann
Lutz Koepnick

With a contribution by
Anne Fritz

SCREEN ARTS AND NEW MEDIA AESTHETICS / 2

Mildred Lane Kemper Art Museum / Washington University in St. Louis

This volume is published in conjunction with the exhibition *Window | Interface*, part of the Screen Arts and New Media Aesthetics series organized by the Mildred Lane Kemper Art Museum at Washington University in St. Louis. The exhibition was on view from August 31 through November 5, 2007.

Other exhibitions in the series:

October 25–December 31, 2006

Support for *Window | Interface* was provided by James M. Kemper, Jr., the David Woods Kemper Memorial Foundation, the Hortense Lewin Art Fund, and individual contributors to the Mildred Lane Kemper Art Museum.

PUBLISHED BY
Mildred Lane Kemper Art Museum
Sam Fox School of Design & Visual Arts
Washington University in St. Louis
One Brookings Drive
St. Louis, Missouri 63130

Editor: Jane E. Neidhardt, St. Louis
Editorial assistant: Eileen G'Sell, St. Louis
Editorial intern: Nicole Keller, St. Louis
Designers: Michael Worthington and Yasmin Khan, Counterspace, Los Angeles
Design assistant: Gretchen Nash, Los Angeles
Printer: Transcontinental Litho Acme, Montréal

Library of Congress Control Number: 2007930319
ISBN-13: 978-0-936316-22-2
ISBN-10: 0-936316-22-5

Cover: Marcel Odenbach, *Das große Fenster (The Big Window)*, installation view, 2001. Courtesy of Anton Kern Gallery, New York.
Back cover: Cerith Wyn Evans, *Think of this as a Window*, 2005. Courtesy of Galerie Neu, Berlin, Germany.

CONTENTS

ACKNOWLEDGMENTS

Window | Interface is the second installment in the Screen Arts and New Media Aesthetics series at the Mildred Lane Kemper Art Museum, which presents exhibitions that explore contemporary art and its relationship to new technologies. Like its predecessor *[Grid <> Matrix]*, which opened in October 2006, *Window | Interface* is designed to initiate discourse about the aesthetic specificity of new media art and the effects of advanced technologies on the arts.

Window | Interface would not have been possible without the generous support of the Sam Fox School of Design & Visual Arts, in particular Dean Carmon Colangelo and his commitment to new exhibition programs; the College of Arts & Sciences, which enables some of the Museum's most meaningful collaborations; James M. Kemper, Jr., and the David Woods Kemper Memorial Foundation for essential special exhibition support; the Hortense Lewin Art Fund of Washington University, an endowment dedicated to exhibitions, publications, and related programs; and the foundational support of individual contributors to the Kemper Art Museum.

At the Kemper Art Museum, special thanks go to Jane Neidhardt, managing editor of publications, for her astute editorial support, and to Eileen G'Sell, publications assistant, and Nicole Keller, summer intern, for their editorial assistance. The Los Angeles design team at Counterspace, led by Michael Worthington, deserves recognition for the creativity and collaboration that resulted in the stimulating design of this book. We want to express special gratitude to Rachel Keith, associate registrar, for her work in organizing loans and coordinating the exhibition; to Jan Hessel, facilities manager and head art preparator, and her team for installing the exhibition; and to the rest of the Museum staff, whose continuous collaboration makes Museum programs possible.

We are also grateful to contributing author Anne Fritz; her participation was both a pleasure and an asset. Of the many people who helped with the successful realization of this project, we particularly want to thank: Ann and Steven Ames; Martin Bland; Josie Browne; Peter Campus; Rebecca Cleman; Luc Courchesne; Christopher Eamon; Stacy Bengtson Fertig; Arthur Fleischer, Jr.; Christoph Gerozissis; Melanie Heit; Joanne Heyler; David Hilliard; Benjamin Laugier and the Society for Art and Technology, Montréal; Rose Lord; Iñigo Manglano-Ovalle; Themistocles and Dare Michos; Jude Palmese; Yasmine Rahimzadeh; Robin Rider; Burkhard Riemschneider; Katherine Rodway; Sasha Rossman; Jeffrey Shaw; William Shearburn; Richard Sigmund; Bernard Toale; Leslie Tonkonow; Jeff Wall; Lynn Warren; and Jason Ysenberg. And finally, thanks go to all who lent to the exhibition. Their trust, generosity, and collaboration made the exhibition and this publication possible.

Sabine Eckmann
Director and Chief Curator
Mildred Lane Kemper Art Museum
Sam Fox School of Design & Visual Arts
Washington University in St. Louis

Lutz Koepnick
Professor of German and Film & Media Studies
Curator of New Media
Mildred Lane Kemper Art Museum
Washington University in St. Louis

INTRODUCTION

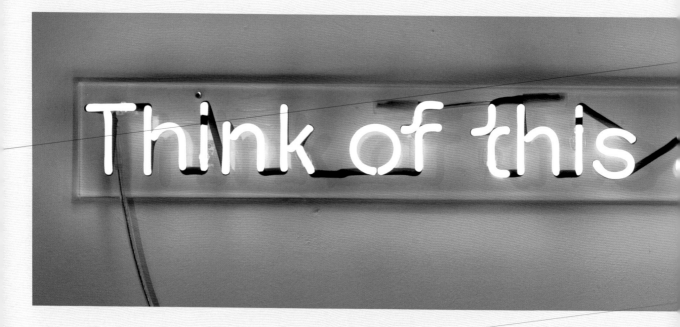

CERITH WYN EVANS
Think of this as a Window, 2005

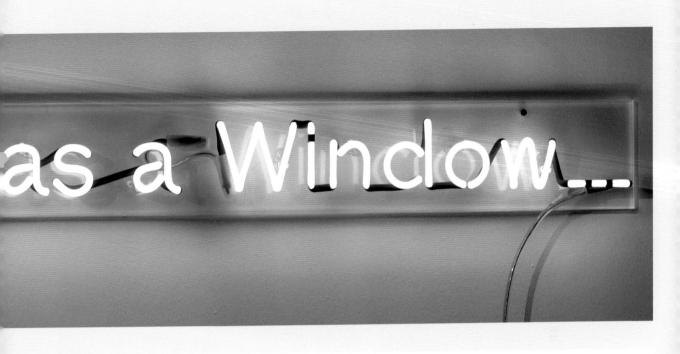

"Think of this as a window. . ." reads a series of neon-lit letters in Cerith Wyn Evans's 2005 work of the same title. The letters appear within a distinctly horizontal and, if you wish, windowlike frame, yet instead of enabling panoramatic views onto the world behind the gallery's wall, Evans's work throws us back onto ourselves and makes us wonder what we might call a window today in the first place. It is difficult to miss the reference to René Magritte's famous *The Treachery of Images* (1928–29), in which the Belgian Surrealist painted the image of a pipe, added in writing that this is not a pipe, and thus invited the viewer to explore the gulf between representation and reality, the image and the imagined. Unlike Magritte, however, Evans presses us to think about the metaphorical range of the traditional notion of the window: the framing and display devices we have come to experience like windows even though, in the strictest sense, they might not be architectural windows at all. Think of our computer screens, our cell phone displays, our low- or high-definition television tubes. Think of the silver screen of your local multiplex cinema. Think of all the monitors—large and small—scattered across our cityscapes, airports, and transportation systems, drawing us into a restless world of news and advertising, spectacle and disaster. Think of your digital camera's tiny display screen or a contemporary museum's engagement with time-based art and moving image culture. Think of the Nintendo Wii console and image allowing you to play tennis with a virtual opponent in not-so-virtual an environment

9

after all. Think of the three dots at the end of Evans's phrase, asking us to envision alternate uses of the concept as if we looked through a window onto distant realities.

Electronic windows are ubiquitous today. Whether stationary or mobile, they serve as interfaces connecting public and private spaces, the local and the global, the present and the past. Whether digital or analog, screens dominate our perception of reality, structure our understanding of identity and ideology, and frame our daily practices of communication, self-expression, and consumption. A series of exhibitions presented over the course of several years, Screen Arts and New Media Aesthetics explores the interpenetration of different screens of representation in contemporary culture. The exhibitions in this series probe the aesthetic uses and historical dimensions of contemporary screen culture. They shed light on how different artists make use of newer media and technologies, how the rise of the digital impacts dominant codes of art, culture, and experience, and how today's screens open alternate views of the past, present, and future.

Window | Interface is the second exhibition in this series. Windows are frames that enable, yet often also disable, contact between interior and exterior realms, between private and public spaces, between the world of the body and the more abstract world of sight or the imagination. The Renaissance relied on the metaphor of the window to anchor central perspective and define the nature of both reality and the image; Renaissance paintings opened windows onto the world and provided reliable maps of the world. Renaissance culture predominantly situated the window-looker as a distant observer casting powerful gazes at the world, a disembodied spectator ordering the messiness of visual space according to geometric principles. Throughout the last two hundred years, this association of windows with distant and disembodied looking has lost much of its former valence, much as we have come to mistrust the idea of central perspective as a system producing quasi-automatic, foolproof, and transparent maps of the three-dimensional world. Modern art, architecture, and culture largely dispensed with the idea of the window as a device safely framing the world and defining clean borders between different spaces.

What we call interfaces today is an updated version of the window. Interfaces are defined as the common boundary between two different systems, a surface at which dissimilar bodies, spaces, or entities touch upon each other. Most frequently, we speak of an interface as that point of contact where machines meet and interconnect with their human users so as to communicate information. Interfaces such as the computer screen, the mouse, and the keyboard are sites of contact and transaction between the abstract and the corporeal, between machine and mind, between data and perception, representation and embodiment. They provide surfaces of virtual transport and dislocation that have the power to carry us to other temporal and spatial orders. Yet, as they connect different symbolic and material spaces, they at the same time may also—like a wall containing a window—separate incompatible realms and screen out unwanted interactions.

Window | Interface focuses on various artistic projects from the 1960s to the present exploring the role of windows and interfaces as media of contact and

transaction, but also as sites highlighting what is interfacial about our bodies and our modes of perception themselves. It illuminates how such artists as Doug Aitken, Cerith Wyn Evans, Gary Hill, David Hilliard, Marcel Odenbach, Hiroshi Sugimoto, and Jeff Wall have addressed the role of windows and electronic screens as media of framed perception and virtual transport. As importantly, it also examines the extent to which different uses of windows, screens, and interfaces in recent and contemporary artworks, videos, and installations by Joseph Beuys, Peter Campus, Olafur Eliasson, Valie Export, Kirsten Geisler, Iñigo Manglano-Ovalle, Charlotte Moorman and Nam June Paik, Jeffrey Shaw, and Bill Viola allow us to experience the role of our bodies as the primary medium of experience, of our senses as windows onto the world, and of our faces, eyes, skin, feet, and fingers as interfaces constantly engaged in redefining the limits of our bodies in relation to the world around us. The spotlight is on windows, screens, and interfaces that situate and stress the viewer's body, not as an immobile, distant, and seemingly omnipotent observer of the world, but as an active, mobile, and often unpredictable medium producing ever-shifting views of the world. *Window | Interface* thus demonstrates how the modern window, the electronic screen, and the digital interface have come to serve as sites underscoring the embodied character of human experience, as well as the fact that we can think neither of the world of digital data nor of human visual perception as something that can exist without a body, without a tactile and sensuous dimension, without an ongoing process of becoming and expiring.

Screen Arts and New Media Aesthetics is designed to stimulate discussion about the aesthetics of the digital and the location of new media art in current research, discourse, and artistic practice. Although publications and exhibitions on new media are wide-ranging and include monographic studies, historical accounts, and theoretical analyses, thematic explorations that connect theoretical discourse with aesthetic forms are still rare. The aim of this series is to provide such a platform. It places electronic art forms side by side with older forms of technological art, such as photography, film, and video, to advance our understanding of how electronic windows, screens, and interfaces today structure aesthetic experience and practice.

SE / LK

FRANZ KAFKA

WHOEVER LEADS A SOLITARY LIFE AND YET
NOW AND THEN WANTS TO ATTACH HIMSELF
SOMEWHERE, WHOEVER, ACCORDING TO CHANGES
IN THE TIME OF DAY, THE WEATHER, THE STATE
OF HIS BUSINESS, AND THE LIKE, SUDDENLY
WISHES TO SEE ANY ARM AT ALL TO WHICH HE
MIGHT CLING—HE WILL NOT BE ABLE TO MANAGE
FOR LONG WITHOUT A WINDOW LOOKING ON TO
THE STREET. AND IF HE IS IN THE MOOD OF NOT
DESIRING ANYTHING AND ONLY GOES TO HIS
WINDOW SILL A TIRED MAN, WITH EYES TURNING
FROM HIS PUBLIC TO HEAVEN AND BACK AGAIN,
NOT WANTING TO LOOK OUT AND HAVING THROWN
HIS HEAD UP A LITTLE, EVEN THEN THE HORSES
BELOW WILL DRAW HIM DOWN INTO THEIR TRAIN
OF WAGONS AND TUMULT, AND SO AT LAST INTO
THE HUMAN HARMONY.

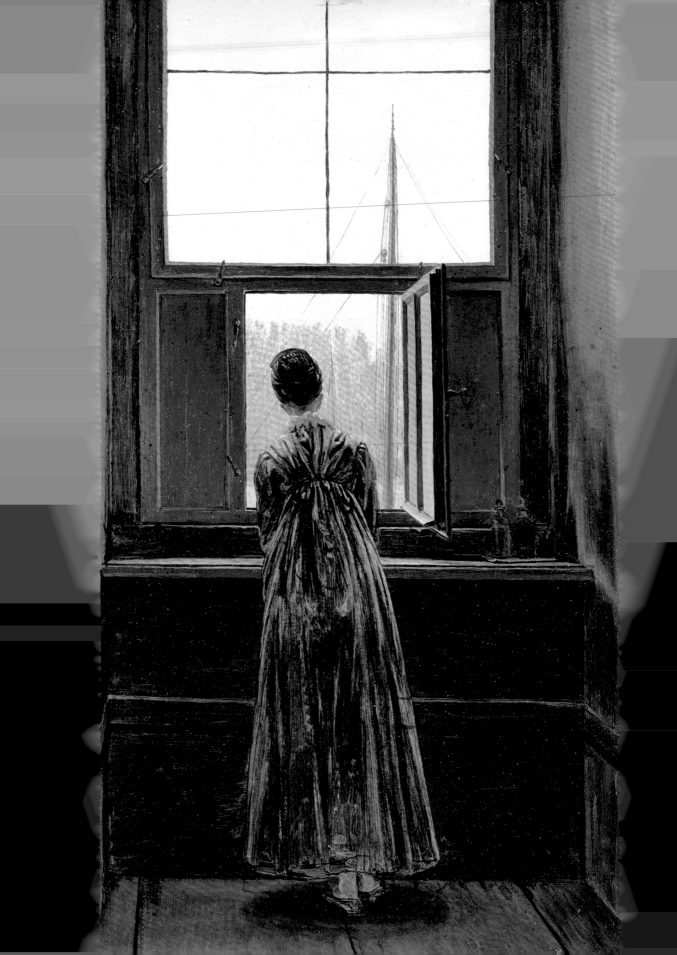

the
AESTHETICS
of the INTERFACE

"Whoever leads a solitary life," Franz Kafka ruminated in a two-sentence text nearly a century ago, "and yet now and then wants to attach himself somewhere, whoever, according to changes in the time of day, the weather, the state of his business, and the like, suddenly wishes to see any arm at all to which he might cling—he will not be able to manage for long without a window looking on to the street."[1] Kafka's vignette engages a well-known Romantic trope so as to present the window as a site separating interior and exterior spaces and precisely thus energizing the subject's hope for escaping his inner isolation, fragmentation, and solitude. As if directly alluding to Caspar David Friedrich's famous 1822 painting *Woman at the Window*, Kafka's text describes the window as a frame allowing the viewer to transcend the confines of modern bourgeois existence and reach out for a life richer in meaning than the one we live in the secluded interiors of our private homes. Like Friedrich's painting, Kafka's text pictures the window not simply as a means of emotional longing and uncontained desire, but as a medium of virtual transport and redemptive energies. Though we might simply think of it as a mere hole in the wall, Kafka's window— similar to Friedrich's—invites the viewer to pass from one kind of world into another. The

Fig. 1.
CASPAR DAVID FRIEDRICH
Woman at the Window, 1822

This essay builds on and reframes a number of arguments I developed in *Framing Attention: Windows on Modern German Culture* (Baltimore: Johns Hopkins University Press, 2007). Many thanks to the students of my spring 2007 seminar at Washington University, "The Aesthetics of the Interface: Media and the Arts as Windows onto the World." Their thoughts and inspiring contributions have been instrumental in helping me rethink and expand earlier conceptualizations of window, screen, and framed perception.

1. Franz Kafka, "The Street Window" (1913), in *The Complete Stories*, ed. Nahum N. Glatzer, trans. Willa and Edwin Muir (New York: Schocken Books, 1971), 384.

window's primary task here appears to be nothing less than to release our minds from the demands of mundane business and carry our imaginations beyond the stubborn imperatives of our physical bodies and material environments. Whoever leads a solitary life and knows how to look through this window can expect to leave his perceived alienation behind and insert himself into a community of others.

And yet, Kafka would not be Kafka if his text did not take a sudden turn and push the reader beyond the worn symbolism of the window as a site of spiritual longing and emotional transcendence. As it further elaborates on the solitary viewer's initial hope for attaching himself to something, the second and final sentence of Kafka's aphorism reads: "And if he is in the mood of not desiring anything and only goes to his window sill a tired man, with eyes turning from his public to heaven and back again, not wanting to look out and having thrown his head up a little, even then the horses below will draw him down into their train of wagons and tumult, and so at last into the human harmony."[2] To use the window in the hopes of clinging to someone's arm, we are to learn from the second half of Kafka's text, clearly exceeds a merely spiritual or immaterial operation. Instead, Kafka's longing for attachment is meant quite literally, the street window enabling the viewer to experience the bliss of both sensorimotor movement and physical contact. Facilitated by the window's frame, sight here is being presented as inherently bound up with the viewer's entire sensory system. Rather than subjecting the observer's other senses to the putatively pristine work of vision, Kafka's window defines the eye as deeply embedded in the vagaries of the entire body, of tactility, of motion, and of touch. Sight here is much too valuable to be left to the organ of the eye alone. What Kafka therefore means when he speaks of attachment is a process of displacement in which the window pulls the observer somatically into the fleeting movements of the street. While some might use the window in order to pursue the voyeuristic pleasure of distant observation, for Kafka's viewer the window's most salient function is to dynamize the place of viewing by placing the viewer as a sentient being in the commotion of the street. Its most relevant function is to enable empathetic and tactile forms of looking, allow us to experience ourselves and our bodies as other, and precisely in this way prepare the ground for us to overcome our solitude and reenter the social fabric.

The English noun "window" derives from the Old Norse "vindauga," amalgamating "vindr" for wind and "auga" for eye and thereby defining windows as membranes for the simultaneous admission of air and light. Much more than a mere aperture framing exterior realities, the original meaning of "window" appealed to multiple registers of sensory perception, including our senses of smell, vision, hearing, and touch.[3] Contrary to how industrial modernity came to privilege the eye over other organs of perception, Kafka's hope for attachment recalls the window's early meanings. Kafka's text describes the window as

2. Ibid.

3. For more on the material and symbolic history of the window in Western culture, see Anne Friedberg, *The Virtual Window: From Alberti to Microsoft* (Cambridge, MA: MIT Press, 2006), and my introduction to *Framing Attention.* For more on notions of embodied spectatorship and the coupling of vision to other sensory modalities, see in particular Vivian Sobchack, *Carnal Thoughts: Embodiment and Moving Image Culture* (Berkeley: University of California Press, 2004); Laura U. Marks, *Touch: Sensuous Theory and Multisensory Media* (Minneapolis: University of Minnesota Press, 2002); Caroline A. Jones, ed., *Sensorium: Embodied Experience, Technology, and Contemporary Art* (Cambridge, MA: MIT Press, 2006); Anna Munster, *Materializing New Media: Embodiment in Information Aesthetics* (Hanover, CT: Dartmouth College Press, 2006); and Bernadette Wegenstein, *Getting Under the Skin: Body and Media Theory* (Cambridge, MA: MIT Press, 2006).

an opening with the help of which sight can bring viewers in touch with each other and produce bodily responses to the movement of objects across the visual field. Like the Old Norse wind-eye, Kafka's window provides a site of sensory and synesthetic transaction—a mechanism not only allowing us to see with the entirety of our bodies, but transforming the whole body into an eye, a mobile framing device, at once taking in the world and delivering the viewer to the world's unstable spaces and temporalities.

Kafka's window on the street is emblematic of the transformation of the window in modern culture and modernist aesthetic practice. It is part of a concerted effort to overcome the ways in which the Renaissance understanding of image, space, and perspective had sought to extract the observer's body from the visual field, subject the messiness of the visible world to the seemingly universal and impersonal principles of Euclidian geometry, and thus cleanse processes of seeing and representation from the unpredictable operations of the human senses—from flux, movement, contingency, and affect. In 1435, Leon Battista Alberti famously defined a painted image as an "open window" through which we look at the visible world.[4] What Alberti considered a picture categorically separated the space of the viewer or painter from that of the viewed. Pictures, for Alberti, were windows momentarily interrupting the flow of rays between a beholder's eyes and the object of his look, and what one could see on their framed surface visualized a standardized system of lateral lines, vertical planes, receding orthogonals, and vanishing points. As is well known, Alberti's window metaphor prepared the ground for the revolutionary breakthrough of linear perspective during the Italian Renaissance. Though Renaissance theorists and artists developed more than one notion of linear perspective, its general concept quickly came to conquer Western and non-Western image production in the name of objectivism, rationality, and scientific abstraction. And though we can find pockets of resistance against its growing hegemony in Baroque art and seventeenth-century Dutch painting,[5] the principles of artificial perspective and its notion of the window were soon to be seen as an accurate template of how our eyes and brains perceive the world. As W. J. T. Mitchell notes, the effect of Alberti's notion of image and window was "nothing less than to convince an entire civilization that it possessed an infallible method of representation, a system for the automatic and mechanical production of truths about the material and mental worlds."[6]

Alberti's notion of the image as a window onto the world defined seeing as a distanced, abstract, and disembodied method of mapping the world and arresting the flow of time. According to this understanding, what makes images and windows good images and windows is their ability to remove the viewer from being touched by the lures of the physical world; to define human sight as the purest, most self-sufficient, and most distinguished of our senses; to produce universal insights about the deeper structure and

4. "First of all, on the surface on which I am going to paint, I draw a rectangle of whatever size I want, which I regard as an open window through which the subject to be painted is seen." Leon Battista Alberti, "De Pittura" (1435), in *On Painting and On Sculpture: The Latin Texts of "De Pittura" and "De Statua,"* trans. Cecil Grayson (London: Phaidon, 1972), 55.

5. See Svetlana Alpers, *The Art of Describing: Dutch Art in the Seventeenth Century* (Chicago: University of Chicago Press, 1983).

6. W. J. T. Mitchell, *Iconology: Image, Text, Ideology* (Chicago: University of Chicago Press, 1986), 17.

meaning of worldly affairs; and to thus situate the observer as one whose very immobility and disembodiment endows her with omnipotent authority and control over the visual field. Symptomatic of the modernization of fenestral looking in the nineteenth and twentieth centuries, Kafka's window breaks with this conception. His window no longer serves as a mechanism safely framing exterior spaces, imposing order on the contingencies of the real, and extracting the viewer's body from the visible. Instead, the window here serves as a surface where two different worlds—the world of the viewer and that of the viewed—appear to touch each other. Stable boundaries between what is exterior and interior no longer seem to exist. In Kafka's text, the observer's body projects itself into the motion of the street just as much as the street's commotion seems to energize and structure the physiological aspects of the observer's perception. In Kafka's view, the Renaissance concept of the window as a site privileging single, monocular, detached, and seemingly disembodied vantage points has become a matter of the past. Visual perception is now lodged in the vicissitudes of the subject's body, yet this body is at the same time experienced as an integral part of the visual field itself. Windows no longer situate viewer and viewed neatly on different sides of a categorical divide and thus define vision as a purely optical procedure. Rather, the modern window here is being defined as both a surface where body and world engage in tactile exchanges and as the very "technics" by which our perceptual systems perpetually frame and reframe the phenomenal world.[7] Far from merely offering a static site where different symbolic or material worlds can behold each other, Kafka's window situates the viewer's body as the primary medium, a membrane able to mediate different impressions of the real and situating us in ever-different perceptual positions.

To be sure, modernist architects pursued different paths of fenestral innovation: Le Corbusier favored horizontal over vertical windows in an effort to situate the house as a mobile camera able to collect shifting views of the environment; Adolf Loos sought to replace transparent with opaque windows in order to design the house as a self-reflexive apparatus offering competing views of interior space.[8] Kafka's window on the street can nevertheless be seen as symptomatic for the overall modernization of the window and its role in the visual arts since the nineteenth century. Nothing concerning the role of the window here is self-evident anymore, not its role as a threshold between interior and exterior spaces, not its ability to offer structured views of the world and to endow the viewer with feelings of perceptual mastery, not even its location or existence. Whereas post-Renaissance discourse and aesthetic practice championed the window's transparency as a means of offering realist impressions and seemingly detached visions, Kafka—like so many other modernists in all branches of creative production—draws our attention to the material and hence nontransparent qualities of the window. Windows, in this understanding, are never merely neutral or invisible frames of looking. They provide a

7. For more on the notion of a "technics" of perception, see Mark B. N. Hansen, *Bodies in Code: Interfaces with Digital Media* (New York: Routledge, 2006) and *New Philosophy for New Media* (Cambridge, MA: MIT Press, 2004). This essay is considerably indebted to Hansen's work, not least of all his reinterpretation of the phenomenology of Maurice Merleau-Ponty.

8. See Beatriz Colomina, *Privacy and Publicity: Modern Architecture as Mass Media* (Cambridge, MA: MIT Press, 1996), 233–335.

surface or skin at which different symbolic or material worlds dynamically intermingle. They draw the viewer into what turns out to be an unpredictable and utterly unstable series of interactive exchanges and reciprocal transactions. Far from simply offering a static peephole in a wall, the window's material qualities now actively structure our ongoing framing and reframing of the real, whether we think of the perceiver's body and tactility as a window in and of itself or not. What makes a modern window modern, as an architectural as much as a representational configuration, is the fact that its very matter matters, and that we therefore cannot think of it in isolation of the flux and unrest, the dynamic of becoming, being, and disintegration, the volatility and messiness character-izing all matter around and in us. What makes Kafka's window modern is the fact that it approximates what we, in our era of ubiquitous computing and highly mediated connec-tivity, have come to call the "interface," namely, a surface—the screen, the keyboard, the mouse—serving as a common boundary between two different bodies, spaces, and phases, a zone of physical contact where machines and users meet each other and engage in mutual interchanges over time and across space.

The concept of the interface was first used in English in the late nineteenth century, yet it did not really enjoy wider usage until the 1960s, when cybernetic experts and computer designers set out to develop different solutions to enable effective interactions not only between the sphere of digital code and the computer user's cognitive capacities, but also between the physical aspects of computing devices and the user's sensorimotor abilities. Though some hardware and software designers might have prioritized the symbolic over the tactile, as I will discuss more later on, what they all have shared is the understanding of the interface as a space of contact that—like Kafka's window on the street—allows viewers to step into a fundamentally different order of things. As we mostly know them today, interfaces lend a "face" to the computer and the machine, enabling the human hand, eye, skin, or mind to manipulate and interact with the machine's realm of data, information, and code. But interfaces also draw or incorporate the human body into the machine and ask users to retrain their senses in order to improve computer–user interactions. Interfaces are thus best understood as transformational zones between the abstract and the corporeal, between machine and mind, between data and perception, representation and embodi-ment. Although their design often appeals to the Renaissance concept of the window and its rhetoric of infallible truth, realism, and objectivity, human–computer interfaces today—whether small or large in size—draw our attention not only to the fact that even the world of digital code and abstract data cannot exist without a body and material base, but also that our minds will not be able to access this code and data without somehow involving the physiological end points of our sensory organs—the tips of our fingers, the skin of our palms, the motion of our hands or eyes. Unlike the Renaissance window, which was

conceptualized merely from the user's side of action and precisely thus hoped to extract the viewer's body from the visual field, interfaces cannot be understood, one-sidedly, as mere frames enabling and structuring a user's perception or knowledge production. Instead, interfaces are sites of virtual transport and dislocation that have the power to carry us to other temporal and spatial orders while also inserting different orders into our own physical surroundings. Like Kafka's window, interfaces connect and intermingle dissimilar symbolic and material spaces, and in doing so they require users and machines alike to relinquish some of their boundaries and become and be other.

Over the last two decades, we have come to live in a culture of omnipresent electronic windows and interfaces. Haunted by deep-seated fears that computerization could result in a pathological splitting of body and mind, critical discourse in the 1990s was invested in discussing interfaces either as dystopian vortices that would swallow up the possibility of human experience, or as utopian sites of total immersion and virtualization. On either side of the debate, scholars and critics were obsessed with the idea of a fully transparent interface, a digital window rendering invisible its own presence and precisely in this way allowing users to plunge with their entire sensoria into the world on the other side of their screens, keyboards, mice, or cell phone displays. Much of the early hype about transparency and total virtualization has dissipated over the past years and been replaced by a growing interest in how new media reveal the extent to which our phenomenal bodies already operate as interfaces, that is, how our sensorimotor organs follow certain schemes, technics, and operations that allow us to see and perceive something in the first place. Instead of speculating about the perils or pleasures of transparent interfaces, of seamless interactions with machines in the name of total virtualization, today we seem more interested in how certain mechanisms of virtualization are integral aspects of our perceptual systems to begin with—and how certain interfaces can help us further explore and expand on the status of our body and senses as interfaces and windows. Similar to Kafka, the focus is not on how to lose one's senses amid ubiquitous screens, windows, and interfaces, but how to use new media in order to better understand the role of the body as the primary medium of perception and to breach the body's boundaries so as to enable new kind of experiences.

Aesthetics, in its oldest and most original meaning, has less to do with the formal organization and hierarchical ordering of individual artworks than with the procedures and pleasures of sensory perception, with how we at once respond to and produce what presents itself to our sensory experience. As discussed by ancient Greeks and later by eighteenth-century philosophers, aesthetics has first and foremost to do with the perceiver's body and with how certain objects allow the viewer to perceive his or her body and its relation to the world in potentially enriching ways. The omnipresence of electronic

windows and interfaces today has placed new stress in aesthetics on sensory perception and embodiment. In the remainder of this essay, I will discuss various artistic projects that explore the aesthetics of windows and interfaces as sites of contact and transaction, not as something empowering abstract and quasi-disembodied forms of looking, but as something highlighting what is interfacial about our bodies and our modes of perception. The spotlight will be on artistic uses of windows and interfaces that, contrary to the historical reduction of the window to a mechanism of pure sight, allow for a notion of the window as a location of highly unstable, unpredictable, and multisensory transactions, a Kafka-like membrane simultaneously allowing the body to become other and to discover otherness in itself. I will concentrate on four key aspects of the relation of new media art and the viewer's body as a moving medium, window, and interface: how art engages with issues of motion, touch, and bodily boundaries; how artists renegotiate the struggle undertaken by computer designers in the 1960s between concepts of user-friendliness and the coevolution of machine and user; how contemporary media art reconfigures spatial perceptions and structures; and how contemporary artists engage with the temporal horizons of aesthetic experience.

[1]

Suspended from the ceiling, the frame measures one by one meter. It holds about forty vertical strips of reflecting material, set at an equal distance to each other, with as much space in between each strip as is taken up by the width of each strip itself. As we approach the frame, we might first focus on the reflection of our bodies, sliced into fifteen to twenty segments. Because of the arrangement of reflecting bands, half of our bodies are of course missing, a lack we try to compensate for by moving either to the right or to the left. We might—first playfully, then perhaps more desperately—seek to accomplish coherent body images through all kinds of physical movements and activities, but in the end we cannot but fail in our effort to unify the sight of our own seeing. Our bodies will remain ripped into vertical pieces, the frame forever fooling our vanity as much as our need to experience ourselves as integrated and bounded. A second strategy might simply be to ignore our own reflection from the outset and try to look straight through the transparent spaces of the lattice onto whatever lies behind it, that is, use the frame as a window onto the gallery rather than as a mirror of our own positions within the gallery. Once again, as we approach the installation we may find ourselves intentionally or inadvertently moving to the left or to the right in the hope of attaining a full view of what is beyond the screen and thus produce a unified visual field. Yet again we cannot succeed, frustrated by the experience of lack, blockage, and fragmentation. A third and perhaps most likely option is to move toward this frame while alternately looking through and looking at the lattice.

As we switch between approaching the installation either as window or as mirror, we use the sight of our bodies to fill in the holes of the visual field or we employ objects in the distance to supplement what is missing from our bodies. Once again, however, we find ourselves moving in various directions to entertain our eyes with a more unified vision and body image, yet even more so than during our first approach we now might feel startled about the torn sight of our own seeing, of our bodies shifting their locations to interface with both the world and ourselves, and our failure to achieve any sense of perceptual unity, self-presence, or completion.

We encounter a sheet of transparent glass, set up in the middle of a darkened room. On the other side of the glass screen, a closed-circuit video camera records our body in real time and transmits this recording to a video projector situated on our side of the glass. As we approach the glass we see our reflections on the surface of the pane next to or even partially overlapping the life-size image of our bodies cast by the projector, the former—since mirrored—the wrong way round, the latter—since captured and projected—the right way round. We, in all likelihood, will not be able to resist the temptation to match and map the contours of both images onto each other and hence to produce a unified image of our bodies. Yet whatever we do in order to achieve this, wherever we move to see ourselves seeing, the result cannot be other than inconsistent, producing a split and slightly schizo-phrenic, an unsettling and uncanny doubling of body, vision, and image. We may move forward or backward to cause the size and boundaries of both body images to agree with each other, but all things told we find that our desire for coherent scales and contours will never achieve fulfillment. The installation encourages us to face ourselves, to embody our own images and inhabit our body images, but in the end we leave with the strange impres-sion that we were unable to make body and image belong to each other—that our eyes have no power to authorize a conclusive sense of bodily integrity.

In a seminal essay about the phenomenology of the human senses, Hans Jonas wrote in the 1950s: "Sight, in addition to furnishing the analogues for the intellectual upperstructure, has tended to serve as the model of perception in general and thus as a measure of the other senses. But it is in fact a very special sense. It is incomplete by itself; it requires the comple-ment of other senses and functions for its cognitive office; its highest virtues are also its essential insufficiencies."[9] Though seeking to trace the Western privileging of the eye as the most noble of human sense organs, Jonas ends up arguing that we cannot sever sight from touch and tactility when trying to understand the functions of human perception. Sight may have been elevated to nobility because it seems to detach us from causality, affect, and proximity, but it cannot but fail in its task if it is entirely uncoupled from the other sensory modalities, in particular from our ability to confer reality to the phenomenal world

9. Hans Jonas, "The Nobility of Sight: A Study in the Phenomenology of the Senses" (1954), in *The Phenomenon of Life* (New York: Harper & Row, 1966), 135–36; also quoted in Hansen, *Bodies in Code*, 119.

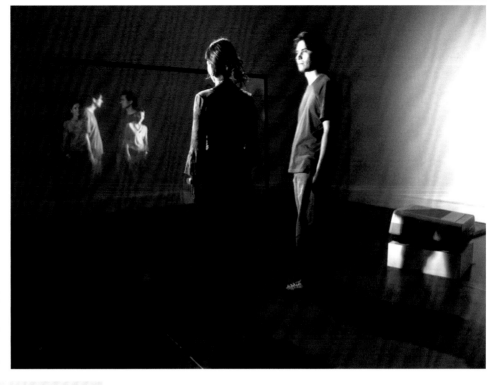

through motion, affect, sensorimotor projection, and our ongoing effort to sense our own physical boundaries. Sight, far from crowning the other human senses, is inextricably embedded in the body's actions, in our ability to map external space into internal dynamic space through the actual or virtual movement of our entire sensoria. Whereas classical and enlightenment philosophy sought to abstract vision from the other senses, seeing only works because it is grounded in our experiential modalities of kinesthesia (the sensation of body movement), of proprioception (the awareness of the body's position and boundaries in space), and of touch (the sensation of physical contact with objects other than the body), all three of which comprise what contemporary phenomenology calls "tactility."

By placing us beside ourselves or asking the viewer's body to fill in the gaps in the perceptual field, the two installations described above—Olafur Eliasson's 2001 *Seeing Yourself Seeing* (p. 60) and Peter Campus's 1972 *Prototype for Interface*—explore the ways in which our sense of sight is embedded in how

PETER CAMPUS
Prototype for Interface,
installation view, 1972

we feel our dimension, gravity, weight, position, and movement in space. We may not be invited directly to touch what we see, but as we find ourselves readjusting our bodily positions so as to alter our self-images and their relation to space, we come to experience nothing other than the phenomenological coupling of sight and tactility. Rather than frame static images of the world and situate the viewer as disembodied, in the work of both artists the window screen reveals the extent to which we must think of our own perceiving bodies as images themselves, as constitutive parts of the image space that surrounds us, much as we must consider whatever we call image as something that owns some kind of body and physical dimension. Confronting us with uncanny doubles of ourselves, Eliasson's and Campus's window frames challenge what we normally consider the given boundaries of bodily existence. In doing so, their installations at once define vision as a medium to experience our own bodies and mobility and identify this moving body as the principal medium to carry out acts of vision. In both installations, the act of seeing ourselves seeing, of turning reflexively toward our own perceptual processes, far from produces a heightened sense of narcissistic self-identification and perceptual mastery. On the contrary, as we try to match different images of our bodies (Campus) or flesh out the fragmented visual field with images of our physical presence (Eliasson), we come to experience sight and tactility as a nonhierarchical dynamic of reversibility and reciprocity, as an open-ended relational structure than can never achieve a sense of completion, closure, or fulfillment. Beguiled by his symmetric and static self-image, Narcissus died because he was unable to reflect on the position and boundary of his own body and therefore was able to love only himself. With the art of Eliasson and Campus, our kinesthetic, proprioceptive, and tactile modalities are put to work in such a way that we experience a fundamental unsettling of our spatial positions and extensions. Continually asked to reflect on the shifting place and boundaries of our bodies, we never arrive at Narcissus's self-enclosed and deadly pleasure. As we explore our act of producing perpetually fragmented self-images, we move beyond whatever could lock us into narcissistic self-identification and move toward what enables us to touch upon the world beyond ourselves—toward what allows us to become and be alive.

The difference between Eliasson's or Campus's intervention and the Renaissance model of window, vision, and embodiment could not be more pronounced. Recall Albrecht Dürer's famous drawing of a draughtsman drawing an image of a reclining female nude, published in a textbook about proper draftsmanship in the early sixteenth century. His eye arrested by a vertical stick, Dürer's artist scrutinizes his model through an observational lattice, his hand simply copying the "image" that he sees through the window frame onto a piece of paper. The draughtsman's gaze is shown as serenely unaffected by the object of his look. Stick and window-grid define his space as untouched by the untidiness of desire and what

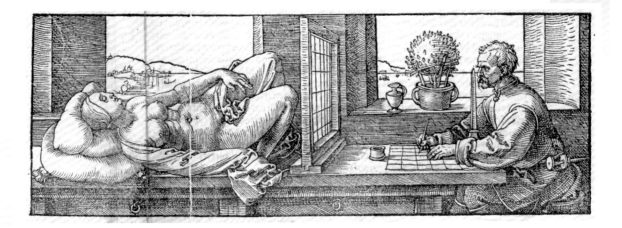

could violate the operations of scientific objectivity. Facilitating the proper execution of geometrical perspective, the window's frame and grid here not only produce a seemingly methodical and hence accurate representation of the world, they also define the observer as a rational, unmoving, and unmoved monarch over the dynamic of the visual field.

Compare Dürer's grid to Eliasson's lattice! Whereas in Dürer's representation the frame's assumed transparency is essential in removing the draughtsman from the phenomenal space and presenting his activity as an act of pure looking, Eliasson's window draws our gaze to its very materiality—to that which prevents it from ever achieving utter transparency—while stressing the role of our sense of bodily motion, place, and corporeal contour in the generation of visual images. If Dürer situated sight as humanity's most noble and most powerful sense because it kept us out of the messy realms of touch and physical contact, Eliasson's window positions the viewer's sense of tactility as the principal frame of visual experience, thus situating body and space in a nonhierarchical, contingent, and fundamentally unpredictable relationship.

Though we do not have direct physical contact with Eliasson's and Campus's work, it is our tactile sense—the projection of possible contact that anticipates and accompanies each and every one of our movements—that in both installations essentially generates and authenticates the image of the space around us, of one's own body and of this body's acts of seeing. In both works, the nontransparent aspects of the window and frame encourage us to explore our own position in and our active production of space, the role of our physical dimension, weight, gravity, and volume in our processes of seeing. In both works, in more than merely a metaphoric sense, we end up touching and being touched by the image that we see and thus upset what the modern museum largely represses, namely, the

ALBRECHT DÜRER
Man Drawing a Reclining Woman, 1538

KIRSTEN GEISLER
Dream of Beauty—Touch Me,
details, 1999

we could and should expect from the role of electronic interfaces in new media art and digital culture today. In its very disavowal of blissful reciprocity, *Dream of Beauty—Touch Me* preserves the utopian promise of bliss embedded in our encounter with both the beautiful and the dislocating force of the interface.

[2]

Many have come to think of the computer interface mostly as something that works best if it renders itself invisible or at least recalls the look of long-familiar work or entertainment environments. In 1965, computer scientist Ivan E. Sutherland referenced Alberti's metaphor of the window to describe this dream of interface transparency: "One must look at a display screen as a window through which one beholds a virtual world. The challenge to computer graphics is to make the picture in the window look real, sound real, and the objects act real."[11] Sutherland envisioned the computer interface as a surface whose primary purpose was either to make users believe that whatever they did to affect visual representations on screen also moved some kind of real entity, or to allow virtual worlds to achieve unmediated effects on the user's perception. Both conceptions envisioned the interface as a self-effacing conduit that enabled spontaneous and intuitive contact between human and computer. In both conceptions, users could relate to the world of machines without knowing anything about their formal operations.

Though this model of the interface has dominantly informed the work of computer developers ever since, it was certainly not the only model developed in the early days of interface design. Consider the work of Douglas Engelbart. Though essential for the later development of the mouse, the windowed user interface, and the hypertext format, Engelbart's research in the 1960s ran counter to mandates of user-friendliness and instead was guided by concepts such as coevolution and coadaptation, that is, the idea that technological improvements would transform the user's capabilities to think, feel, and manage complexity, and that hardware and software designers, by inventing new forms of artificial intelligence, would also reinvent the human user rather than merely cater to presumed needs and existing forms of cognition and sensory self-expression.[12] Unlike Sutherland, Engelbart did not envision the computer screen as a device empowering the untrained to manipulate data in the most efficient way. On the contrary, for Engelbart, the user was to employ computing technologies to develop new ways of thinking and of exploring his or her own bodily and human identity. Whereas Sutherland's work sought to situate the computer as an intuitively commensurable tool, Engelbart's interface offered a third space in which users could become other without losing sense of what made them different from the machine. Opposed to dominant

11. Ivan E. Sutherland, "The Ultimate Display," in *Proceedings of International Foundation of Information Processing*, ed. Wayne A. Kalenich (Washington, DC: Spartan, 1965), 2: 506.

12. "Engelbart's work was based on the premise that computers would be able to perform as powerful prostheses, coevolving with their users to enable new modes of creative thought, communication, and collaboration providing they could be made to manipulate the symbols that human beings manipulate. The core of this anticipated coevolution was based on the notion of bootstrapping, considered as a coadaptive learning experience in which ease of use was not among the principal design criteria." Thierry Bardini, *Bootstrapping: Douglas Engelbart, Coevolution, and the Origins of Personal Computing* (Stanford: Stanford University Press, 2000), 143.

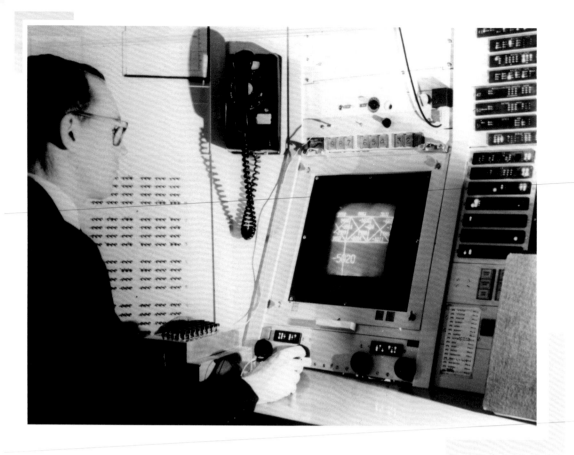

templates of user-friendliness, Engelbart envisioned the interface as an artificial limb bridging, but never closing, the gap between the organic and the artificial—a performative space that provided the possibility of insight and self-transformation.

Sutherland's and Engelbart's seminal visions about the interface have informed the computer industry ever since the 1960s in its efforts to develop ever-more sophisticated software solutions and hardware designs to improve the interactions between computers and their users. Such developments, however, have not simply been driven by different technological or economical concerns. Similar to Sutherland's and Engelbart's initial concepts, they are also energized by competing ideas about the user's perceptual modalities and modes of aesthetic experience, about how our bodies relate to the world around us and how neither the computer nor human vision and intelligence can be entirely abstracted from their material or sensory base. Dominant Western notions of frame and window, as embraced in the wake of Alberti's seminal Renaissance definition, considered different apparatuses of framing—the camera obscura, the photographic camera, the film

Fig. 2.
Ivan Sutherland using a
CAD program on the TX-2
computer, 1963

30

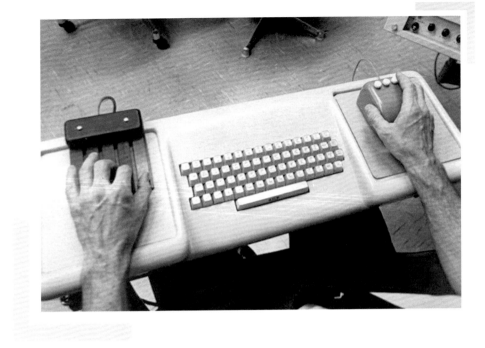

screen—as devices at once defining and narrowing the experiential field so as to produce an object for a subject or subject the looking subject to the object of the look. At their best, computer–human interface designs, as informed by the research of pioneers such as Sutherland and Engelbart, have sought to undo this narrowing of the frame, open up the visual and experiential field, and in this way redefine the viewer as a decentered one who is neither a mere effect of the visible world nor an authoritative master over what might appear at the end of the frame's perceptual funnel. At their best, interfaces have thus redefined the perceptual frame, not as a visual tunnel, but as an unstable, ephemeral, and mobile surround in which the viewer's viewing and his being viewed are simultaneously constituted as something that eludes anyone's absolute control—as an open field in which our perceptions and pleasures exist through the existence of everything around us and will always escape the Renaissance window's rhetoric of totalization, stability, and separation.

It is this decentering negotiation of technology and aesthetics, the framed and the unframed, the visible and the invisible, that is at the core of installations such as Jeffrey Shaw's *The Golden Calf* (1995; pp. 32–33). The work consists of an unassuming white museum pedestal and a handheld LCD monitor that is attached to the pedestal, waiting to be picked up. As we lift the monitor from the pedestal, the screen shows the image of a calf on a pedestal that resembles the pedestal right in front of us. As we move the monitor and

Fig. 3.
A demonstration of the "Mouse" with
Douglas Engelbart, 1968

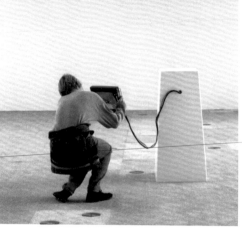

our bodies away from the (real) pedestal, the image of the calf and the (virtual) pedestal shrink in size; if we change our viewing height and angle in relation to the (real) pedestal, the sight of calf and pedestal on the screen will change accordingly. We find ourselves circling the real podium with the monitor in hand, testing out different viewing positions and perspectives, actively moving the frame of vision to produce different framings of the virtual calf. Every once in a while we might wonder what other museum visitors think about us as we move around this empty plinth engrossed by something that eludes everyone else's gaze. We might turn our eyes away from the monitor and behold people around us viewing with some astonishment our own viewing. But quickly we return to the image on the screen in our hands again, circle the void in front of us, and enjoy the pleasures not only of calling forth images through motion but of our mobility itself and its ability to produce images that neither arrest nor cut down the visual field to the size of a static frame. We allow the monitor to become our prosthetic eye much as we permit the calf's virtual, albeit effective, presence to make us test out different bodily postures and motions. Though nothing could be more framelike than the monitor in our hands, what we thus experience is both an undoing of the limiting power of the framing apparatus and a momentous decentering of our vision and viewing bodies within the surrounding field.

Similar to Sutherland's interface, Shaw's screen seems to enable an intuitive and spontaneous relationship to the world represented by computers. Even without knowing anything about the apparatus's code and programming, we can nevertheless without much hesitation manipulate what appears to us. Yet as if glossing Engelbart's conception of the interface,

JEFFreY SHAW
The Golden Calf,
installation views, 1995

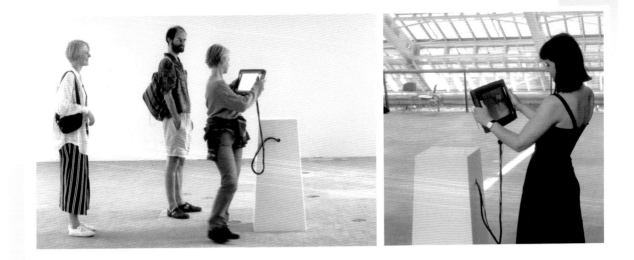

Shaw's monitor at the same time opens up a third space of coevolution in which both a computer's artificial intelligence asks us to adapt our bodily operations and our desire to see something induces the computer to revise its frame of representation. As it undoes the inherent narrowness of conventional framing devices, Shaw's interface situates the computer as the user's prosthesis much as he invites us to become the machine's prosthetic extensions. In this way, it opens up a new kind of surround in which we can experience ourselves and our viewing as something unportentous, impermanent, and other—in which we can relinquish our usual quest for authoritative mastery and instrumental control without becoming subjected to what might be ungovernable, authorial, and utterly contingent in the world around us.[13]

In the Hebrew Bible, the golden calf was a cultic object made by Aaron in order to bridge Moses's prolonged absence from the Israelites, yet it quickly became an autonomous idol that violated the Second Commandment, namely, the ban of images used to worship Yahweh. In its effort to define the interface as a mobile surface of decentered viewing and coadaptation, Shaw's installation makes ironic use of the Biblical tale. Not only does he liquefy the fixity that is at the heart of any form of idolatry, but in doing so he also brings to earth what idol worshippers consider the idol's aura, that is, a worshipped object's unique appearance of "a distance, however close it may be."[14] After all, the golden calf we help produce on Shaw's monitor is nothing other than a virtual image, a computer-generated special effect, and once we tear our view away from the monitor and exit the interface's third space of prosthetic reciprocity, all we of course come to see is a space of void, absence,

13. For more on the notion of portentous and unportentous viewing, see chapter 4 of Sobchack, *Carnal Thoughts*, in particular her adaptation of the work of Keiji Nishitani and Norman Bryson.

14. Walter Benjamin, "The Work of Art in the Age of Mechanical Reproduction," in *Illuminations: Essays and Reflections*, ed. Hanna Arendt, trans. Harry Zohn (New York: Schocken, 1969), 222.

and emptiness. Yet Shaw's irony is less directed at religious traditions per se, as it instead takes issue with the cult of image and object that continues to structure the history of art, the art market, and the art museum today. As it opens the frame, decenters the viewer, and situates object and viewer in an uncontainable surround, Shaw's interface envisions forms of future art emancipated from the stifling traditions of the past—an art of unfixity, ongoing transformation, potentiality, and becoming; an art in which we learn to relinquish our desire for control without being struck by catastrophe, trauma, and violence; an art in whose context bodies can mimetically adapt to what is inorganic as much as the artificial can be infused with the human; an art in which we can engage in a playlike encounter with the visible without entirely losing our sense of everything that envelops us on all sides, yet cannot but remain invisible.

[3]

"There is," Charles Baudelaire wrote famously in the 1860s, "nothing more profound, more mysterious, more fertile, more sinister, or more dazzling, than a window, lighted by a candle. What we can see in the sunlight is always less interesting that what transpires behind the panes of a window. In that dark or luminous hole, life lives, life dreams, life suffers."[15] For Baudelaire, windows provided engines of fantasy production. They allowed the creative mind to make up stories about the world and thus flee into some alternate reality. Like poetry itself, a lighted window invited empathy and identification, not because it depicted the real realistically, but because it awakened the viewer's projective energies, our yearning to infuse visible objects with our own soul and corporeality. In today's age of ubiquitous electronic screens and digital windows, Baudelaire's candles have largely gone out of business. The window's former luminosity, its mysterious glow, has largely been replaced, not only by the dull shimmer of our computer screens, but also by our ability to conjure endless images at will and without much imagination, with the proverbial click of the mouse. Digital or not, has the window today lost its ability to bedazzle? To engross us with something that at once radiates profundity and activates our imagination? To spark dreams of an existence richer in meaning and effervescence than the one we call, for lack of a better word, our life on this side of the screen?

If we asked contemporary photographers such as Canadian Jeff Wall, the answer in all likelihood will be in the negative. Primarily presented in the form of transparency light box displays, the material properties of Wall's images recall Baudelaire's desire for fenestral illumination and dazzle. Due to their mysterious glow and intensified color compositions, Wall's large images fill us with wonder about the life transpiring beyond the frame and display pane. Like Baudelaire's window, they show us a world more bountiful in meaning

15. Charles Baudelaire, "Windows" (1864), in *Prose and Poetry*, trans. Arthur Symons (New York: Albert and Charles Boni, 1926), 63.

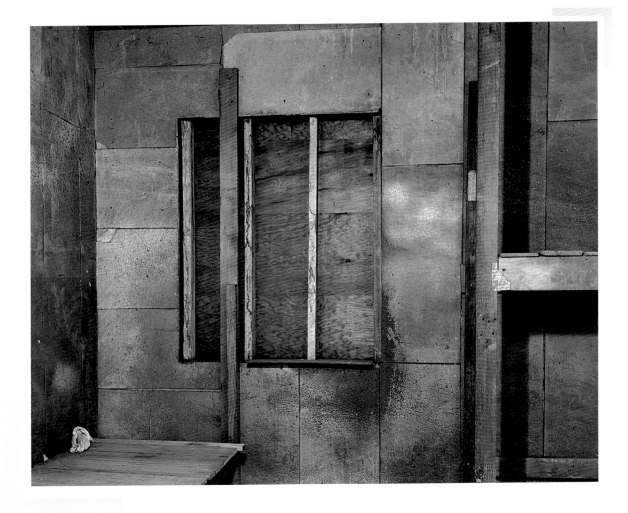

and sensual attraction, in imaginative potential and mysterious actuality, than our own very ordinary one. And yet, in photographs such as his *Blind Window* works from 2000 (pp. 35, 36, 85), Wall's camera captures a world whose denial of fenestral looking—the shutting down of framed views onto anything at all—radiates disaster triumphant. There is no doubt plenty to see in these light box transparencies: the structural and textural clash of wood and concrete is dramatic; the compositional tensions between vertical and horizontal lines fascinate; the multiplication of frames within the frame causes our eyes to search for ever-new points of focus; and the juxtaposition of cold and warm colors offers our view a panoply of different zones of affective looking. But in the end, we encounter all this only as a pale substitute for what the images no longer show: the perspective through a window onto a world in which life and matter might unfold and thus engage our imagination, our

JEFF WALL
Blind Window No. 2, 2000

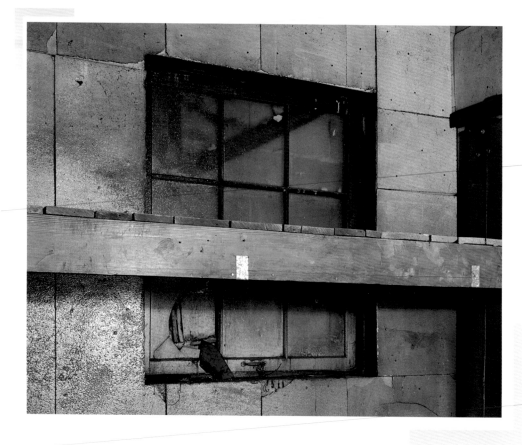

affect, our hope for a different future. Even when Wall presents windows that invite rather than block our view into the distance, as in the stunning 2004–5 *A view from an apartment*, it is difficult not to detect symptomatic signs of sensory deprivation and claustrophobic closure, of obstructed vision and experience, of blindness and spatial shrinkage, of catastrophe and a profound absence of profundity scattered across his photograph's surface.

Two women occupy the neatly choreographed space pictured in *A view from an apartment*, one reading a journal on the couch on the right, the other walking in socks toward the camera, her eyes on the laundry basket on the left, her hands holding a small piece of cloth, her whole demeanor giving the impression we caught her in the middle of cleaning up the rather cluttered domestic interior. Staged through and through, the apartment offers the viewers' eyes little to hold onto and focus their attention. Like the woman on the left, our gazes remain forever on the move, vacillating between different zones of compositional density and various tools of framing within the frame such as the television screen on the

JEFF WALL
Blind Window No. 1, 2000

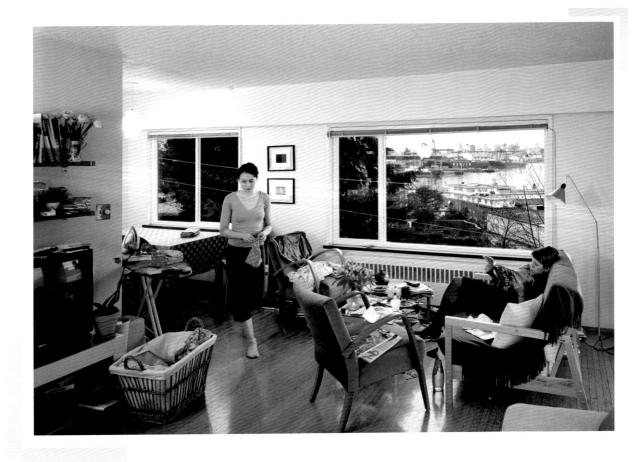

left, the two pictures frames on the wall in the rear, and, of course, the two partitioned windows, the right one of which opens our view onto an industrial harbor scene, yet—similar to its reflection of the interior lamps—causes our gaze to return to the apartment's interior again. No matter how domestic in nature, the whole arrangement has something utterly unsettled and uncanny. No matter how much both windows potentially allow light and life to traverse the apartment's perimeters, they underscore the image's dual sense of insulation and fragmentation. Interior and exterior spaces appear as distanced and estranged as the lives of both inhabitants, their bodies and eyes oblivious to each other's presence. Neither on this nor on the far side of the window does life seem to live, dream, or suffer. Like the dystopian sight of the harbor itself, whose waters show no sign of moving ships, both the window and the apartment seem to inhibit rather than inspire any animating transaction, traversal, or transformative movement. Aside from the heat, Hell cannot be much worse than this.

Fig. 4.
JEFF WALL
A view from an apartment, 2004–5

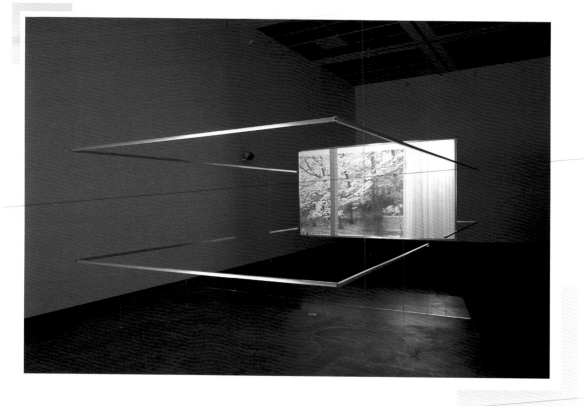

If the *Blind Window* photographs, by picturing rooms without any view whatsoever, come to express Kafka's greatest torment, namely, to live a solitary life without possible attachments, *A view from an apartment* suggests that even the existence of grand panoramic windows might do little to enable dissimilar spaces and trajectories to touch upon each other. Space here is pictured as an aggregate of virtually disconnected planes and surfaces of action, as a nonmetric and heterogeneous field that defies any notion of unity or coherence. Unlike Alberti's image and window, which suggested visual homogeneity and metric regularity because they constructed the visual field from a singular vista, Jeff Wall's light boxes fragment space into a multiplicity of disjointed zones, planes, axes, and structures, each of which seems to follow its own logic and all of which refuse to add up to an integrated whole. Instead of positioning the viewer at the end of a visual cone and constructing perspectival lines accordingly, Wall presents space as an accumulation of different aspects, an assembly of distinct looks. We do not even need to substantiate what we suspect all along—namely, that Wall digitally manipulated the image of the harbor in the window and then inserted it into his photograph—in order to recognize the composite nature of space and its ultimate absence of extension and depth. Similar to Microsoft

IÑIGO MANGLANO-OVALLE
Le Baiser (The Kiss),
installation view, 1999

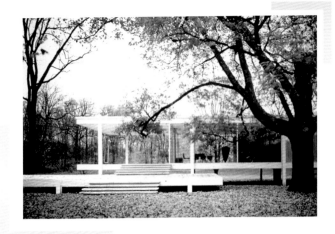

Fig. 5.
LUDWIG MIES VAN DER ROHE
Farnsworth House, 1951

entrepreneur Bill Gates's architectural visions, according to which electronic screens will replace traditional windows, allow inhabitants to access vast image banks, and enable us to conjure appropriate sights matching our mood and will,[16] Wall's window denies the hope both Kafka and Baudelaire invested into fenestral visions: the hope of being drawn from one space into another, of discovering mysterious connections and unexpected links between adjacent spatial orders, rather than merely leaping from one discontinuous aspect to another while being condemned forever to surf the surface of the visible, never transcending the stasis of the intentional and deliberate.

A similar sense of spatial isolation and disenchantment at first appears also at the center of Iñigo Manglano-Ovalle's video installation *Le Baiser* (*The Kiss*). The video was shot in 1999 at Mies van der Rohe's Farnsworth House in Plano, Illinois, an iconic exemplar of modernist architecture and its various attempts to redefine our places of dwelling as media capturing shifting views of our environments. The title of the installation recalls one of the first films ever shot, an 1896 Edison release with a run time of roughly one minute showing nothing other than a couple kissing each other. Projected on both sides of a screen, Manglano-Ovalle's video opens with a spectacularly beautiful view of an autumn scene as seen through the glass walls of the Farnsworth House. Soon, we witness a window washer (played by the artist himself) as he cleans the house's wide expanse of exterior glass while we also see a female, although somewhat androgynous, person inside, dressed entirely in red, wearing headphones and manipulating portable DJ equipment. Though window washer and dweller are close to each other, separated only by the transparent glass, they do not seem to acknowledge their respective presences, both of them locked into different perceptual orders, both of them occupying incongruent class positions.

16. Bill Gates, with Nathan Myhrvold and Peter
Rinearson, *The Road Ahead* (New York:
Viking, 1995), 205–26.

Chilling silence accompanies the footage shot from inside the house, while we hear the sounds of crackling leaves, the window washer's squeegee, and nondiegetic guitar music (played by the rock band Kiss) when the camera is outside. Cinematic conventions cause us to expect something extraordinary to happen: an act of seduction or violent transgression, a moment of epiphanic recognition or sudden role reversal. Yet no such rupture occurs. No matter how close their proximity, window washer and DJ remain encapsulated in their different worlds, and the window, instead of enabling some kind of contact, continues to operate as a screen, a protective surface filtering out unwanted or uninvited connections. Whereas the window washer, as he eagerly restores the building's emphasis on breathtaking sight, appears caught up in a logic of pure and public visibility, the dweller has chosen to dwell in an alternate and solipsistic universe of private sound.

And yet, while the projected images and sounds of *Le Baiser* (*The Kiss*) eternally delay what the title of Manglano-Ovalle's work promises, the installation's spatial setup might allow us as viewers some sense of operative interfaciality after all. Manglano-Ovalle's double-sided screen is surrounded and framed by a suspended aluminum structure that mimics the modernist interplay of windows and walls in the Farnsworth House itself. Contrary to the film's image of the architectural window as an impassable and hence restrictive divide between solitary individuals, the installation allows us to traverse its defining boundaries: to enter the structure on one side and behold the projection; to move around the aluminum frame and look at the video from the other side; to test out and inhabit different relationships to the window screen and thus render permeable what in the video appears confined to static positions. We are certainly not able, by changing our distance and viewing angle, to change the narrative trajectory of the film and somehow compel the two protagonists to recognize each other. What we do succeed in, however, is emancipating our own act of viewing from the logic of sensory enclosure staged in the video itself, its embargo on polysensory perception and trajectory practice. As we move in and out, toward and away, along and around the frame that surrounds the installation's screen, we come to experience this screen, not as a device preventing unwanted interactions, but as a potential surface of contact and passage. The modern and postmodern reconfiguration of the window may no longer allow us to perceive space as homogenous, systematic, or lodged in one dominant point of view. It may instead—like Jeff Wall's window frames—strike us as heterogeneous and aggregate, an inconclusive sum of incongruent aspects, planes, and zones of visibility. But as we traverse Manglano-Ovalle's installation in ever-different directions and—unlike the film's protagonists—situate ourselves on either side of the screen, we seem to recuperate some aspects of Baudelaire's nineteenth-century vision of the window for our own time and future.

GARY HILL
Still from *Windows*, 1978

Modernist glass architecture and the ubiquity of electronic screens in digital culture may both have eclipsed the poetry and luminosity of candlelight. But as we circle through and around Manglano-Ovalle's installation, struck by the video's radiant colors and lush photography, as we enjoy the work's suggestive beauty with more than one channel of our sensory system, how can we possibly not feel a sense of dazzle and mystery? How can we not be electrified and thus carried beyond ourselves by what windows—old and new—might have to offer to us? How could we, when traversing this installation, think of Baudelaire's notion of the window as merely a thing of the past and not expect our future windows, frames, screens, and interfaces to illuminate how life lives, life dreams, and life suffers?

[4]

The camera veers from one side of the room to the other, slowly panning over the windows that separate interior from exterior space. In spite of the camera's ongoing motion, however, parts of the image remain static: the initial image of the window remains visible even though the camera pans away from it, its irregular colors reminiscent of what we see when we close our eyes after looking at a source of bright light. As if image and afterimage were fused into one. As if different temporalities and representational layers—actuality and memory, present and past—appeared within one and the same space. As if it had become entirely unclear whether we see some exterior reality or see the seeing of our own eye—or both at once, restaged with the help of advanced recording technology.

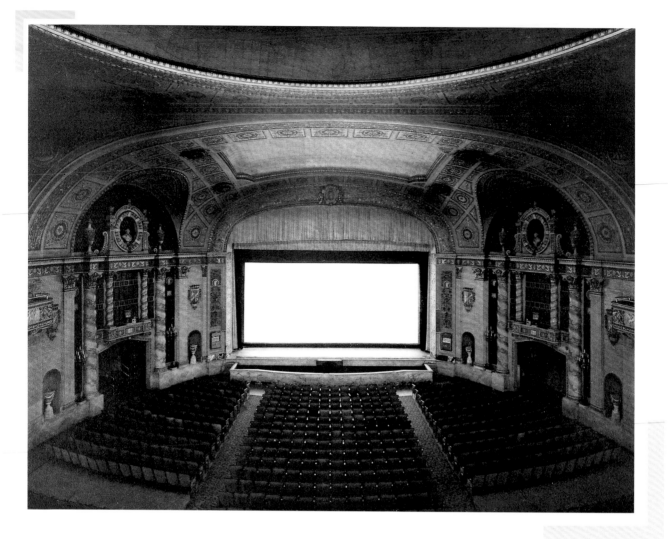

HIROSHI SUGIMOTO
U. A. Walker, New York,
1978, 2000

42

Gary Hill's 1978 video *Windows* (p. 41) is part of a body of work exploring the formal manipulation of color images with the help of camera obscuras and electronic image processing devices. Well before the advent of the personal computer, in *Windows* Hill experimented with the mixing of analog and digitized images into densely layered and increasingly abstract compositions. In what might be seen as an ironic nod to the metaphorical Western understanding of images as windows, the time-based art of video here assumes some of the graphical and compositional properties of painting. Mapping different pictorial layers on top of each other, the video camera and image mixer become brushstrokes of sorts. They not only displace the indexical qualities of the photographic image, they also emancipate pictures of time and motion from the regime of linear progression and instead infuse them with a multiplicity of durations and simultaneous temporalities. What we see is present and past at once, chronological and interior time, a dense layer of nonsynchronous moments and perceptions presenting space, not as fixed, but as a crossroads of competing and often uncontainable itineraries.

In Hiroshi Sugimoto's theater project (pp. 42, 44, 45), pursued since the 1970s, the camera, time after time after time again, captures what was no doubt the most fascinating window of the modern distraction industry—the movie screen—but it does so at locations spread out across the globe. The resulting images are all energized by the same concept: to picture a movie theater's screen during the duration of an entire movie with the camera's shutter wide open, or, to be more precise, to picture the entire duration of a movie, thus producing images in which the theater's screen itself—due to the ongoing reflection of different shades of light—turns out to be entirely white. Blank, albeit mysteriously glowing. Vacated, and yet a trace of "too much." Void of all that normally matters to us when going to the movies. A bright hole in the middle of a moderately lit auditorium.

Whether shot in Los Angeles, New York, or Tokyo, the vast majority of Sugimoto's theater shots are taken from a central point of view. In most of these photographs the screen's luminous square takes up no more than a fifth or a sixth of the image, in such a way that we also behold the theater's interior architecture and how it frames the frame of the screen. Sugimoto always leaves us in the dark about the kind of films his camera transforms into mysteriously glowing rectangles. Nor does he ever picture theaters packed with viewers, their gaze directed at the screen's window, their bodies transfixed in their chairs, their appearance serving as our avatars within the image. What is clear, however, despite such enigmas, is the fact that these images engage their viewers in startling negotiations between different temporalities and durational extensions, and that by not allowing us to subject our desires to the narrative drive implied by the screen, the photographs push the medium of photography toward its very limits. Sugimoto's images are sites of stunning

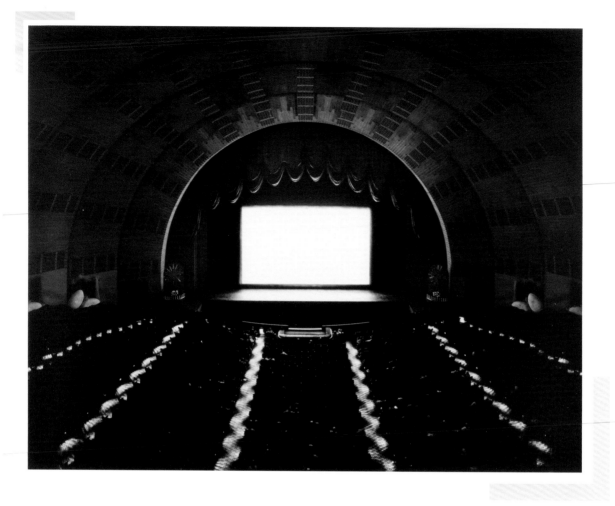

perceptual reversal and transposition, of ironic juxtaposition and irresolvable multiplicity. In each of these images, the screen's seemingly transcendental luminosity is a product of Sugimoto's utterly proficient technological manipulation and his attempt to overturn photography's indexical dedication to the Now, the uniqueness of the moment. Whatever, in this series of images, at first might appear as mysterious and hermetic is a product of Sugimoto's conceptual impetus, his analytical rigor and precision. As with the grail of Wagner's *Parsifal*, time here seems to turn into space, yet nothing should make us think that we can own spatialized time, grasp it like an object, stick it into our pockets to carry it home like a trophy. Similar to Hill's work, space here is and remains as intractable as the flux of time.

HIROSHI SUGIMOTO
Radio City Music Hall, 1977

44

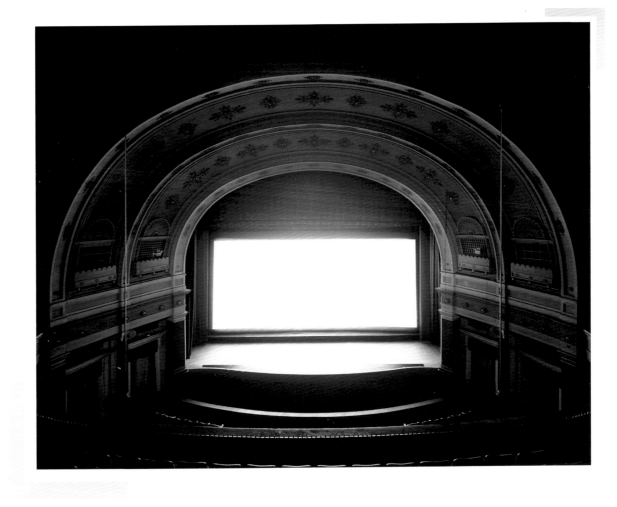

Electronic screens have multiplied in recent years and decades, not only in sheer number and size, but also in how they internally organize different types of images and symbolic materials. To have various windows simultaneously open on our computer desktops has become the norm, whether these windows allow us to manipulate texts, images, music, or travel in virtual form to distant places. No television newscast today apparently can do without the use of various internal screens of information: live tickers on the bottom, insert windows presenting reporters in far away places, text boxes displaying news no anchor has time to announce anymore. In the early twentieth century, the copresence of discontinuous or noncontiguous elements of representation was the stuff avant-garde dreams were made of: he who fractured the visual field hoped to rupture the confines of bourgeois society,

HIROSHI SUGIMOTO
Goshen, Indiana, 1980

45

situate the viewer as an active producer of meaning, and thus unleash politically emancipatory energies from the processes of aesthetic communication. In our age of obsessively split screens and multiplied electronic windows, the avant-garde hope for a fracturing of the visual field has come to full fruition. Yet it would of course be cynical to think of Microsoft, Apple, or CNN as today's spearheads of political activism and radical social reform. Mike Figgis's much-discussed film *Timecode* (2000), telling in real time and on four screens simultaneously what is a fairly vacuous story of Hollywood vanity, provides ample evidence not only of the extent to which the avant-garde dreams have become the everyday, but also of the fact that there is nothing emancipatory or disruptive about the formal splitting and rupturing of the visual or representational field, that formal experimentation per se today no longer can claim a distinct politics, that no medium or window of presentation owns its message anymore.

Both Gary Hill's and Hiroshi Sugimoto's work can be seen as interventions into our culture of split screens and fenestral multiplication. Both involve the viewer in what David Bolter and Richard Grusin have called remediation, the deliberate incorporation of certain media into other media.[17] Hill remediates the medium of the window and its historical role as a model for the image-making process within the "newer" medium of video; Sugimoto makes the time-based art of film the object of the "older" medium of still photography. In both cases, strategies of remediation serve the purpose to implode rather than expand the omnipresence of screens, frames, and electronic windows in our present: they render possible a certain recentering of our attention, situating medium and image as windows that absorb us rather than overwhelm our perceptions with unbound multiplicity and calls for continual action. Though Hill's and Sugimoto's work is unlikely to produce the kind of sensory effects and mobile forms of spectatorship discussed earlier in this essay, their videos and photographs make visible the temporal nature of perception, the ways in which each present presents itself to our eyes as an open-ended simultaneity of multiple durations, temporalities, and ongoing stories.

Unlike the temporal overdrive of our historical moment, in which ubiquitous screens and interfaces shout for our highly distracted attention and invite us to supplant the long breath of personal interactions with the dream of instant connectivity, Hill and Sugimoto show us the present as one that is and can never be entirely present. The window, here, functions neither as a device to frame static views of space nor as a tool to arrest time and thus—like Dürer's drawing contraption—abstract the viewer from the viewed. Instead, what it brings to view is a profound mingling of interior and exterior time, the subjective and objective, image and afterimage, perceived space and process of perception. In the work of both Hill and Sugimoto, the window brings to view something no human eye could ever see as such,

17. See Jay David Bolter and Richard Grusin,
 Remediation: Understanding New Media
 (Cambridge, MA: MIT Press, 2000).

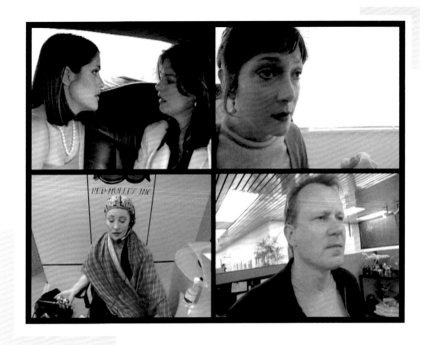

Fig. 6.
Stills from Mike Figgis,
Timecode, 2000

and in doing so, it endows media with the ability not only to both represent and intensify the work of human perception, but also to remind us of the incommensurable wonder and creativity of perception, the wonder of seeing, sensing, hearing, smelling, and touching something in all its flux and ephemerality.

[5]

"To think," writes Rainer Maria Rilke in his novel *The Notebooks of Malte Laurids Brigge* in the first decade of the last century, "that I can't give up the habit of sleeping with the window open. Electric trolleys speed clattering through my room. Cars drive over me. A door slams. Somewhere a windowpane shatters on the pavement; I can hear its large fragments laugh and its small ones giggle. . . . A girl screams, Ah tais-toi, je ne veux plus. The trolley races up excitedly, passes on over it, over everything. Someone calls out. People are running, catch up with each other. A dog barks. What a relief: a dog. Toward morning there is even a rooster crowing, and that is an infinite pleasure. Then suddenly I fall asleep."[18] This passage from Rilke's modernist novel at first seems to describe an

18. Rainer Maria Rilke, *The Notebooks of Malte*
 Laurids Brigge, trans. Stephen Mitchell (1910;
 New York: Random House, 1982), 4–5.

utterly painful and traumatic situation. Unable to shut his window at night, the perceiving subject, Malte, is no longer able to distinguish between interior and exterior spaces, between body and world, between the visual, the acoustical, and the haptic. Struck with insomnia, Malte's mind seems to encompass the entirety of the street and its noises, as much as the urban landscape seems to inhabit and traverse the innermost parts of his body. He is the street as much as the street is him. Window and world become one as much as the subject's wandering attention itself functions like a window, a membrane enabling the impression of polysensory contact and transaction. Trying to find rest, all Malte can thus accomplish is restlessness. Though his physical body might not move at all, his kinesthetic, proprioceptive, and tactile modalities are in full motion and turn him into a thoroughly unsettled and seemingly boundless subject.

Yet what in Rilke's novel at first looks like a traumatic breakdown of conventional boundaries at the same time of course also allows for the possibility of aesthetic experimentation and innovation. The whirlpool of different sensory perceptions, the inability to define and maintain reliable body boundaries, the sense of ongoing motion and displacement: for Rilke, all this also becomes a site for pushing his artistic medium—language—into some new territory. What truly overwhelms Malte as he tries to sleep with his windows wide open is not simply the contingent noise of passing trams or barking dogs. What strikes and unsettles Rilke's hero is first and foremost the contingency of language itself, the way in which words, rather than signifying external referents, have come to reference nothing other than themselves and thus transport the poet into a realm of at once liberatory and frightening indeterminacy. Body, window, and world here fuse into one unity, allowing for a new intensity of perception but also suspending any former sense of protection. The poet's body itself is experienced as a medium, an ever-shifting frame of perception that absorbs a multitude of impressions from the world as much as it delivers the poet to this world. Everything here seems possible, nothing appears to follow any protocol or expectation, with perhaps one exception: the terror of insomnia. Forget about finding respite when joining Rilke's world of heightened intensity and indeterminacy. Expect to give up any expectation for a temporary and tranquil shutting down of the windows of perception. To close the window, in Malte's and Rilke's worlds, means to wipe out a world, means to wipe out us as the producers of this world.

Though written nearly a century ago, Rilke's *The Notebooks of Malte Laurids Brigge* anticipates both the horrors and potentials of our own age of omnipresent

electronic windows and interfaces. On the one hand, screen culture today may certainly be described as a culture of literal and metaphorical insomnia. Continually put in touch with diverse and distant realities, we find ourselves subjected to the imperatives of ongoing accessibility and connectivity. If we follow the logic of contemporary hardware and software providers, we shut down our whole world and thrust ourselves into utter isolation whenever we turn off our electronic screens, our image banks, our sound archives, our online communities, our digital telecommunication devices, and our GPSs. On the other hand, as exemplified in the work of media artists such as Campus, Eliasson, Geisler, Hill, Manglano-Ovalle, Shaw, Sugimoto, and Wall, screen culture today may also provide interfaces that permit new bodily experiences and perceptual modalities, a creative unsettling of physical boundaries and the possibility of unscripted interactions between viewer and viewed. Instead of subjecting the observer to the authority of the world, or situating the world as a mere object of a powerful observer's eye, this art explores our perception as an open-ended process that constitutes subject and object in the first place and enables fluid interactions between the different elements of the experiential field. Instead of erasing the materiality of the human body with the help of advanced technology, this art asks us to reconsider and expand our notion of the sensuous, namely, to think of technology and the organic, of media and sensory perception, of image and body, of frame and world, not as categorically opposed but as mutually implicated and intertwined. Contemporary interface culture, in the perspective of this art, may at times render us sleepless. More importantly, however, it also holds the potential to do what artistic practice and aesthetic experience at their best have always done: to push the limits of our sensory perception beyond given frames of reference; to make us see, see ourselves, and see our own seeing in new light; and to cause us to rethink what we consider the nature of human perception and thus the nature of the human subject itself.

LK

RAINEr MArIA RILKE

TO THINK THAT I CAN'T GIVE UP THE HABIT OF SLEEPING WITH THE WINDOW OPEN. ELECTRIC TROLLEYS SPEED CLATTERING THROUGH MY ROOM. CARS DRIVE OVER ME. A DOOR SLAMS. SOMEWHERE A WINDOWPANE SHATTERS ON THE PAVEMENT; I CAN HEAR ITS LARGE FRAGMENTS LAUGH AND ITS SMALL ONES GIGGLE. THEN SUDDENLY A DULL, MUFFLED NOISE FROM THE OTHER DIRECTION, INSIDE THE HOUSE. SOMEONE IS WALKING UP THE STAIRS: IS APPROACHING, CEASELESSLY APPROACHING: IS THERE, IS THERE FOR A LONG TIME, THEN PASSES ON. AND AGAIN THE STREET. A GIRL SCREAMS, AH TAIS-TOI, JE NE VEUX PLUS. THE TROLLEY RACES UP EXCITEDLY, PASSES ON OVER IT, OVER EVERYTHING. SOMEONE CALLS OUT. PEOPLE ARE RUNNING, CATCH UP WITH EACH OTHER. A DOG BARKS. WHAT A RELIEF: A DOG. TOWARD MORNING THERE IS EVEN A ROOSTER CROWING, AND THAT IS AN INFINITE PLEASURE. THEN SUDDENLY I FALL ASLEEP.

WINDOWS
on PHOTOGRAPHY:
DAVID HILLIARD

I. *Andreu*

One arm, one hand enter from the left. This is where I begin. Fingers rest upon the painted window frame. Perhaps they are opening the panel at the start of the day, pausing while their owner determines sun or rain, short sleeves or long. The light looks fresh, the day young. I picture a standing figure to the left of the hand, centered in the open space, looking out at the city. The grain of the wood is focused sharply enough to make me feel its roughness; I imagine a collection of splinters if the hand were to move too hastily across the surface. The focus of Hilliard's camera situates me. I am right there. I am simultaneously where the towels hang in full detail, where the hand re-emerges in shadow form, where the towel is clutched against a face. The cord stretched across the window is within my reach but the buildings across the street are apart from my realm entirely. They are blurred backdrop. Here is where it is happening, here is where the story is unfolding.

DAVID HILLIARD
Andreu, 1996

53

Hilliard directs my sight. But to what end? Multiple frames allow me to feel nearer to an understanding of the subject. It is as if I am in the midst of a photographed panorama where sight in the form of a general overview has been temporarily unfixed to focus on specific, seemingly mundane details: textures, receding lines, the part of the mirror where the silver back has been damaged. As with a traditional panorama, I see almost all the way around, may see multiple sides of the room at once, yet Hilliard's meticulous specification of detail—this you may see in perfect focus, this will remain blurred—leaves me conscious that focus has been chosen rather than granted universally. Though three panels could allow me to take in multiple perspectives, multiple visions, I am really seeing multiple instances of a unified vision in which some things are left murky for the sake of clarifying others.

54

The viewer wants to pull the frames together; the frames themselves even seem to want to join. The hand is separated from the triptych's center image by the bounds of the camera's frame, but seeps to the middle (and ultimately to the right panel) nonetheless. It is there in reflected form. Maybe the man pictured was not before the open window taking in the day at all, but has just finished showering and has merely reopened the window to release collected damp air. Or maybe he is only grasping at the window frame as a support while dabbing at his forehead with a cool towel on a hot day. The details are so crisp it is as if I have entered the images and am there myself. Through Hilliard's framing and pulling of detail, I am able to see all at once— things that might even singularly have gone completely unnoticed. I contort my own hand trying to mimic the photographed hand's angle, reach across my body to an imagined window frame to my left. I peer into an imagined mirror in

DAVID HILLIARD
Home, Office, Day, Evening, 2006

front of me to see if the angles match. I am drawn into the photograph by Hilliard's details, by this hand that manifests itself threefold.

When is all this happening? Being composed of three distinct rather than one continuous panel, *Andreu*'s frames of panorama could have been made seconds, minutes, or days apart from one another. Potentially noncontiguous spaces and places have been aligned, with towels perhaps in reality not alongside the mirror at all. One or even two of the three panels may be restagings of a first. Which came first, which part of a continuous gesture am I viewing? I know all the details and I know none of the details.

The large window onto the world of *Andreu* created by the three panels is none other than a triptych of mystery and multiplicity. The more information is provided, the more the story could move in any direction. It is an offered view at once single and varied that requires me to fasten everything together in my own mind. Photography taunts with real elements drawn into a world of fiction. Crispness of focus only lures me into the story Hilliard has chosen to share with me and is as much a view into and onto Hilliard as it is onto his subject, *Andreu*.

II. *Home, Office, Day, Evening*

Home, Office, Day, Evening (pp. 54–55) functions similarly, diagonals from either side panel running into each other in the center panel to direct us to a woman's gaze. Here, an arm and hand enter from the right. They clearly belong to the little girl standing at the triptych's right edge. Rather than resting on a wooden window frame, fingers rest on a back, and it seems again that this one gesture could be that which reveals the whole scene. Yet the gesture of the little girl's hand on the woman's back is really not focused. It reads instead as the gesture that has just previously held focus, or that is about to gain focus. It leads us to another connection, that of eyes in abundant mirrors. Perhaps this is where the negotiation of the hand gesture has continued. Is it a touch of comfort, of support, of encouragement to enter the next room for a new activity? Is the little girl pushing the woman to or pulling her from the mirror? An image of one in front of many mirrors would usually be a view onto narcissism. We might expect the woman to be gazing into her own eyes. These seven bits of mirror, though, refract the woman's gaze instead of reflecting it as steady. The very mirrors that might have secured her vanity instead function to alter the entire meaning of the photograph, drawing us instead back to the little girls who observe her.

I trace the focused glances, check in the mirrors for clues to clarify the scene, but the glances are ambiguous, the story manifold in possibility. The joined window is

inconclusive. No single frame tells a full story, and, read against each other, the frames open into a play of meaning.

III.

A potential full panorama is always out there. The frame of the photographer's camera determines what we will see, what our window onto a given space will be. In Hilliard's work, the camera's frame itself is only an initial view. Our windows onto the worlds of *Andreu* and *Home, Office, Day, Evening* are created through the focus within each frame. It is by assembling parts from each of the panels that we are able to form a more complete story. The panels relate to one another, are to be taken in together; their juxtaposition is what creates a whole.

In day-to-day life we constantly negotiate where we will align our sight and ultimately our energy. We can each look from a window out onto a square of land and find something that we as individuals deem worthy of our attention. The act of offering focus itself is an act of granting power and importance; some things we see while others we see past. Selective focus is a daily part of life—seeing past a friend's bad habit to a generous heart, past a desire to a need. How we focus, what we focus on, and how we pull these assorted components together, once granting them our attention, shapes the stories of our days.

David Hilliard shows us how a day might look if we chose his specific sites of focus. He benefits from photography's supposed ability to hold things still, then juxtaposes frames and focus so as to elude this idea of stationary gaze, to allow focus onto multiple points within a panorama. We are shown the individuality of sight as if looking onto a scene through his imagination and experiences. We see the brief registering of individual elements coming together to form a negotiated space. He reveals that even within the frame of a camera, nothing is fixed, as the photographer's eye ultimately pulls things in or out of focus. He could even substitute entire panels—we would not know. We see only that relationships within the frame are put into motion as our sight travels from focus to focus, decoding bits of story.

Space reveals itself as an ongoing process of negotiation. Even in leaving an initial frame for minutes or seconds to position the camera and determine a new focus, a space changes. The overlaps must be renegotiated as they come together, and in the mind of the viewer, will later be enlivened once again. The encompassing window holds movement.

Anne Fritz

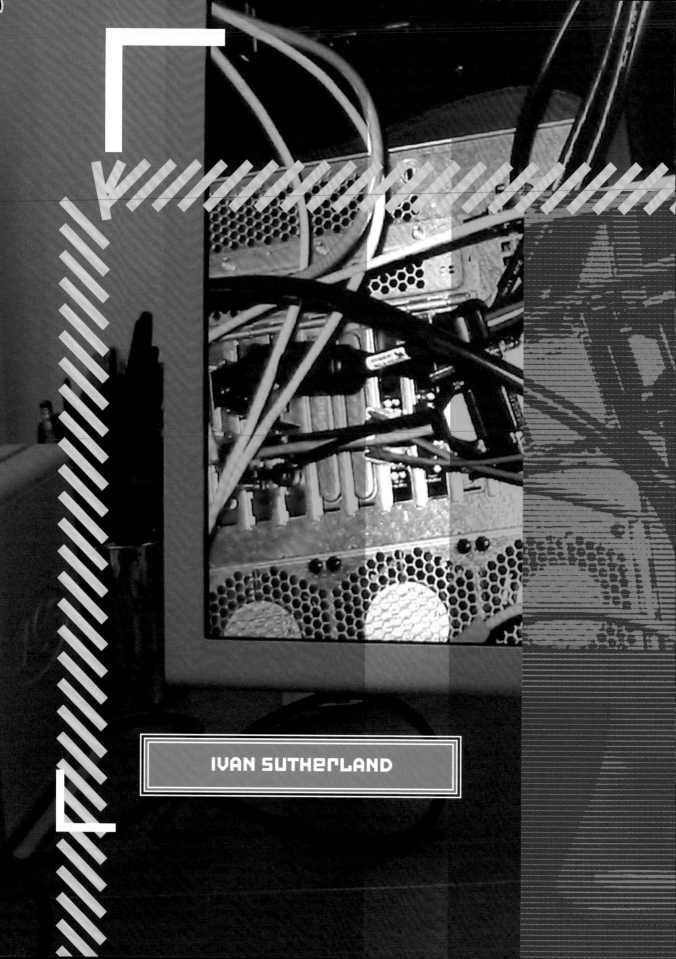

IVAN SUTHERLAND

ONE MUST LOOK AT A DISPLAY
SCREEN AS A WINDOW THROUGH
WHICH ONE BEHOLDS A VIRTUAL
WORLD. THE CHALLENGE TO
COMPUTER GRAPHICS IS TO MAKE
THE PICTURE IN THE WINDOW
LOOK REAL, SOUND REAL, AND
THE OBJECTS ACT REAL.

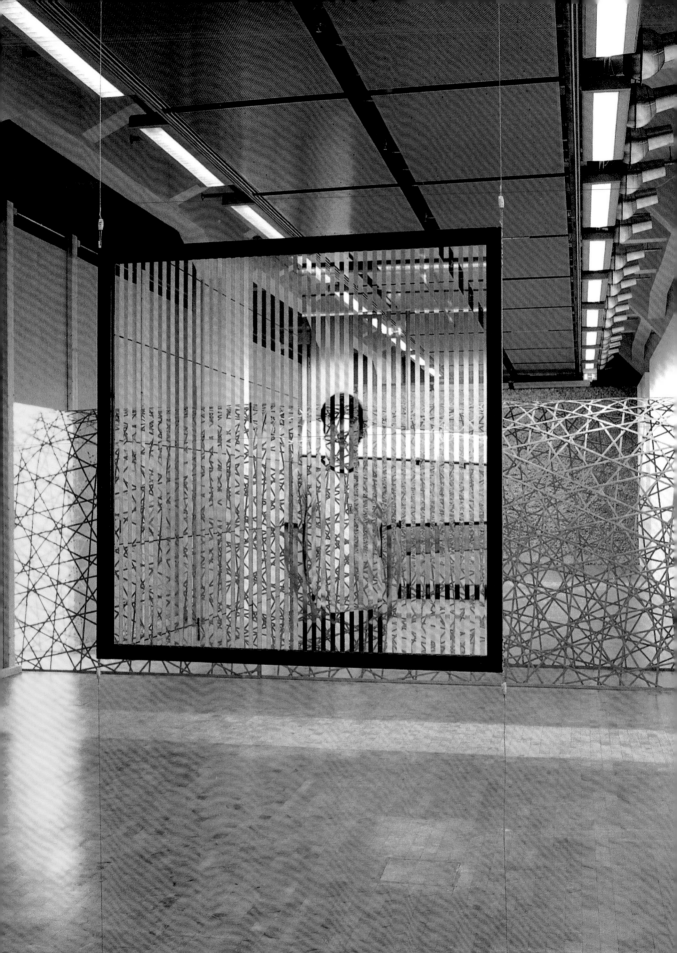

SEEING *and* PERFORMING

Windows, both as material objects and conceptual paradigms of framed sight, challenge us to consider ourselves in relation to the world as a terrain where seeing and being seen is negotiated.[1] They encourage us to engage with the visible and to ask questions about the very nature of vision. What do we see and how do we see? Who is the seer and who is seen? How is visibility constituted? How do images, framed sights, establish relations between subject and object? And how do framed objects determine our experience of self and other, of here and there, in front of and behind? What all such windows have in common is their quality to illuminate a strongly mediated viewing experience. Windows in that sense are surfaces that display already fixed images. Artists, ever since the Renaissance, used one-point perspective or more complicated compositional systems that follow abstract or rational principles of visual organization in order to provide control over the world through framed images. These windows allegedly ensure and secure our place in the world, yet also remove us from interacting with it. Devoid of arbitrariness and chance, the traditional

OLAFUR ELIASSON
Seeing Yourself Seeing,
installation view, 2001

1. Throughout this essay I understand and use the term "framed" in an art historical sense that indicates the status of a painted or otherwise created image as permanent, finished, and self-contained—in short, as one that determines an image as an independent and aesthetic object in order to separate it from the world of banal things. This longstanding tradition, which also suggests the metaphor of the window, was questioned in the late 1950s and 1960s by Frank Stella and others who created so-called shaped canvases—unframed paintings that phenomenologically hovered in-between painting and object and ultimately expanded painting into new realms.

window objectifies, unifies, and symbolizes a static divide between us and the world outside of us, while openly admitting the culturally constructed nature of perception.[2]

Many contemporary windows, however, seem to play tricks on us insofar as they actually obscure rather than enhance sight and perception through the ways in which they frame images. Much of contemporary architecture, for example, employs façades consisting of windows that promise transparent views between inside and outside but are in fact illusive. These windows don't function as a tool that would enable us to see what is behind the translucent surface but, to the opposite, reflect our own images back onto to us, projecting us onto the façades and emphasizing our relation to the spaces and sights we experience. These reflections are often disorienting and short-lived; they not only reflect ourselves as we inhabit various spaces within contemporary urbanity but also instill self-consciousness about seeing and perceiving the world while moving through it.

It is as if these façades have translated into experiential space a contemporaneity that is dominated by a ubiquitous screen culture. In contrast to the conventional window that consists of static views, screens—the movie screen, the television screen, yet also the computer screen, for example—allow us to experience ourselves as performing spectators as we respond to continuously changing images or alter them ourselves. Not seldom do the immaterial worlds projected onto screens capture our attention through sequential images that we often simply consume; while they might evoke desire and emotion, given their unstable nature and fast-changing pace, they also enable us to reframe the world. As much as they are capable of providing immersive sensual experiences, so too do they speak to us as distanced and critical spectators. These screens open up encounters that are located in an in-between realm, a third space that is distinguished by perceiving and experiencing, framing and reframing, as well as representing and experimenting.[3]

Furthermore, much of contemporary art not only engages screens such as the television, computer terminal, or cinema display, it also employs flat LCD screens, entire gallery walls that function as receptors for large-scale projections, and freestanding or hanging screens in various forms and shapes that allow for multiple projections at once. It is not uncommon for these screens to be placed in such ways that to engage with them means to experience them through movement, thus underscoring an aesthetic experience that is both open and malleable. Spectator and aesthetic object are not divided as autonomous entities but interrelate with each other. Similarly, these screens don't deliver framed images or windows that are already imbued with meaning and significance, but, by contrast, encourage us to create images ourselves, as short-lived and contingent as they might be. Moreover, they invite us to immerse ourselves in an experience that leaves behind the

2. Many of the ideas and concepts developed in this essay were stimulated through conversations and discussions with Lutz Koepnick. Especially relevant are his *Framing Attention: Windows on Modern German Culture* (Baltimore: Johns Hopkins University Press, 2007), as well as Anne Friedberg's *The Virtual Window: From Alberti to Microsoft* (Cambridge: MIT Press, 2006).

3. See Doreen Massey, *For Space* (London: Sage Publications, 2005), 29.

purely cognitive act of framing sight and, instead, engage us as embodied beings in order to bring us directly in touch with our spatiotemporal situations, and actively push us to contribute to its constitution. These experiential forms of contemporary screen culture are far from static perceptual contemplations: they promise multisensorial experiences that engage simultaneously a multiplicity of (often moving) images, body movement, and at times also touch and sound. To call these artworks aesthetic representations might be incorrect; we rather want to understand them as experiential experiments involving performing spectators and unstable sights.[4]

In contrast to the conventional window, these installations continuously reframe sight and fixed images in order to engender a multiplicity of subjectivities, sensibilities, and sensual encounters, ones that stimulate new ways to constitute an open interrelation in-between subject and object. Importantly, these artworks involve both temporal and spatial experiences that implicate each other through a dynamic simultaneity.[5] This may happen by moving through such installations while, for example, watching a video. Being unable to either see the complete video or contemplate the whole space, we find ourselves in a contingent situation, struggling with incoherent and fragmented experiences. These involve a variety of distractions, as we encounter an architectural situation, watch action on a screen, and come across other visitors. As we will see, these performative occurrences encompass both embodied and disembodied forms of aesthetic experience. In such situations, the spectator-turned-actor recuperates all of her senses in order to open up to, or, better, reconstitute her interaction with the world, and thus experiences what Maurice Merleau-Ponty has called "lived engagement."[6] Both time and space in such situations are unfixed and cannot be separated, which allows for new configurations in-between the experiential and visible that call for a multiplicity of interfaces—screens, actual spaces, bodies—often transgressing the materiality and stability of objects and sites, and instead connecting spectator and artwork through unpredictable and indefinite ways. It is often the body of the performing spectator, her actual movement and touch, that locates her in an aesthetic sphere bearing many semblances to everyday experiences. In contrast to the traditional concept of the window as providing a permanent and homogenous image that in turn produces a unified and universal subject, these aesthetic encounters make space for different and embodied subjectivities.[7] Conceptualizing our contemporary world as one flooded by images, which to a certain extent transforms the world into an immaterial market space, an embodied spectatorship may be understood as to restore human agency through the ways in which it locates us within the social and political fabric of life.

It is the task of this essay to chart the extent to which a variety of artworks, most of which were executed between the early 1970s and the present, have complicated,

4. See Caroline A. Jones, ed., *Sensorium: Embodied Experience, Technology, and Contemporary Art* (Cambridge, MA: MIT Press, 2006).

5. See Massey, *For Space*, 9–14.

6. As discussed by Marjorie O'Loughlin in "Intelligent Bodies and Ecological Subjectivities: Merleau-Ponty's Corrective to Postmodernism's 'Subjects' of Education," http://www.ed.uiuc.edu/EPS/PES-Yearbook/95_docs/o'loughlin.html.

7. I am indebted here to Doreen Massey's conceptualization of contemporary experience as one that is built upon an interrelationship between space and time in order to allow different identities to coexist.

critiqued, and expanded on the window as a means of objectifying and symbolizing sight. Moreover, this essay will explore technological interfaces, such as screens and multimedia installations, which have transgressed static and permanent framed images. It will ask how the body as incarnate subjectivity and an organ of mediation performs aesthetic experiences in-between cognition and corporeality, thereby enabling an aesthetic of presentness. It will consider then how perception affects our self-understanding through artworks that encourage an experience set in time and space rather than in an imaginary and enclosed system.

<center>* * *</center>

Since the late 1960s, electronic screens, in the form of television and video art as well as other technological media such as photography, have emancipated themselves as independent genres and have, together with installations, significantly broadened the spectrum of the visual arts. Photography ever since then has dwelled on forms that expand this medium, from one of capturing frozen moments that spatialize time to experimentations with various serial images, making the passing of time and sequence part of the work. Instead of contemplating an image that asks to be deciphered as the result of an individual creator, the spectator is now most often confronted with time-based images, a series of photographs, films, or installations that require body movement and emphasize contingencies, fleeting moments, and unstable images. These artworks also undo the security we experience when viewing, for example, a painting, a finished object, as we need to become active ourselves and experience new forms of reception and reflection. Similar, yet more radical, is the field of art since the 1990s; not only do artists demonstrate renewed interest in working with advanced technology, they—in contrast to the late 1960s and 1970s—erase the specificity of various media. Photographs acquire painterly qualities, for example, and leave us wondering if they are digitally manufactured or depict an actual situation. Maybe more important is the phenomenon that many installations hover in-between video, photography, architecture, design, and any other possible form of creation. They indeed testify to what Peter Weibel has termed a post-media condition.[8] Although theorists such as Friedrich Kittler have argued that the post-media state is a result of a thoroughly digitized world comprised of floating data that threatens the materiality of different media and their distinctions,[9] it of course also implies that art is not primarily about framing abstract sight anymore. Along these lines, theorists such as Mark Hansen have argued that the denigration of former conventional and static art forms has directed attention to an embodied experience, which replaces the abstract power of sight. Post-media art, following Hansen, instead attests to examinations of the possibilities and potentials of the affective body.[10] In fact, artworks that thematize unfixed forms and appearances are various and often include the

8. Peter Weibel, "Zur Geschichte und Ästhetik des digitalen Bildes," in *Bilder in Bewegung: Traditionen digitaler Ästhetik*, ed. Kai-Uwe Hemken (Köln: DuMont, 2000), 214.

9. Friedrich Kittler, *Gramophone, Film, Typewriter*, trans. Geoffrey Winthrop-Young and Michael Wutz (Stanford: Stanford University Press, 1999), 1–2.

10. See Mark B. N. Hansen, *New Philosophy for New Media* (Cambridge, MA: MIT Press, 2004). My discussion here, however, deviates from Hansen's theory of the affective body insofar as I discuss bodily encounters as highly contingent and unstable experiences.

body as an interface to guide in the encounter with spatiotemporal ensembles. These open artworks situate viewers in-between seeing and experiencing, immersion and distance, self-presence and representation in an aesthetic experience that is corporeally constituted. Such spatial ensembles, multimedia installations, or interactive computer screens offer us the opportunity to slip into a multiplicity of roles through which we may interrelate with new experiential spaces—both real and virtual—that enable us to create short-lived, transitory images as well as produce affective experiments so as to respond to and reflect on an external world that reveals itself as a universe of fluctuating images.

[LOOKING THROUGH WINDOWS]

On a daily basis, we come across windows that as physical and transparent barriers seem to nevertheless provide us with a host of possibilities of how to create relationships with our immediate and often changing surroundings. We encounter them frequently in our homes, in our offices, and while moving in a car. These seemingly fragile surfaces direct us to engage with the world through the very specific and cognitive activity of framing sights. In contrast to mirrors—which we primarily use to glimpse reflections, most often ones that reproduce our likeness within or without a contextual setting—windows are sites from which to perceive the world and to negotiate our relationship to it. Yet they also look back at us, transform us into a still image, act as a surveillance tool, and, given their size and shape, define what we can see. Windows, we may argue, represent a sort of dysfunctional interface that imparts yet also traverses the divide between subject and object, between inside and outside, and between private and public. On one hand, windows are crossing points that allow us to frame, and thus distance ourselves from, the spaces we inhabit. On the other, they also restrict our interactions with experiential reality as they deliver the world through already framed and fixed images. Ultimately, they structure the relation between those who look and those who conceive what is to be seen, and we may experience ourselves in both of these roles. As much as they empower us to draw a line between private and public, between ourselves and our environments, and thereby signify our control over sight, as much do they also articulate the penetration of the outside into the private sphere behind the window. Windows always do both: they include and exclude us in relation to the social and political contexts of which we are a part. They support us in our role as viewers while concurrently subjecting us to already framed sights.

Above all, artistic representations of windows thematize the act of framing sight. Caspar David Friedrich's Romantic painting *Woman at the Window* (1822; p. 14), for example, examines within a surprisingly strict geometrical and rationalized composition the window as a facilitator for fabricating framed images. Most striking in this respect is

the square window above the woman looking out of an opened window, the title of the artwork underscoring the woman's centrality to the artist's concern. The gridded window is divided into four sections that create four separate views of the sky, similar to a painted image. In this manner, Friedrich paradigmatically illuminated the window as a tool to perceive, contain, and control the visible so as to demonstrate that it is a construction in the first place. We may furthermore want to understand the woman, with her back to us, as ultimately replicating us, the passive viewer in front of a painting who is trying to decipher and contemplate an already conceived image. As much as the woman looking out of the window has little or no control over the appearances she perceives, so too is the aesthetic experience in front of still images one that is guided by the creative subjectivity of the artist. Friedrich tellingly withholds from the viewer the sight on the other side of the window so as to underscore the artist's, rather than the viewer's, ability to contain the visible. We, the spectators, don't engage our senses in such a way that we frame and structure sight ourselves and thereby experience ourselves as subjectivities, but rather we engage with constructions of sight as created by others. This loss of and longing for subjectivity, of course, articulates the extent to which Friedrich was invested in an enlightened Romanticism and its often scrutinizing belief in transcendentalism. With this painting, Friedrich thus defines the engagement with windows as vehicles to frame views as a highly abstract and rational endeavor—one, however, that awakens yearning for a more sensual or embodied subjectivity. What Friedrich does is teach us how windows provide mediated and constructed viewing experiences.

In a similar vein, yet in the dress of contemporary technology, Marcel Odenbach's 2001 video *Das große Fenster* (*The Big Window*) reminds us that sight is always framed and mediated.[11] When originally installed in the Kunsthalle Zugspitze, it was set in front of a spectacular panoramic view over the mountains of southern Germany not far from Adolf Hitler's domicile Berghof. The video installation presents a montage of historically tainted images that are framed anew through different windows. These images, in the form of film clips, date back to the Third Reich and range from Hitler at the Berghof, to short glimpses of the *Erste deutsche Kunstausstellung* (First German Art Exhibition) at the Haus der Kunst in Munich (1937), to clips taken from Leni Riefenstahl's documentaries about the 1935 Nuremberg Party Rally and the 1936 Olympics. In Odenbach's montage we see these ideologically inflected Nazi images through a curtain, as if to remind us of a distant past; we see through a gridded window many times divided and split into a multiplicity of fragmented images, as if to illuminate their ideological character; yet we also see more or less unmediated or unaltered through a large window pane. Employing these different forms of windows and screens, Odenbach dissects the extent to which ideology may be deconstructed by means of montage and reframing.

11. For a more comprehensive and in-depth reading of this video, see Koepnick, *Framing Attention*, 195–99.

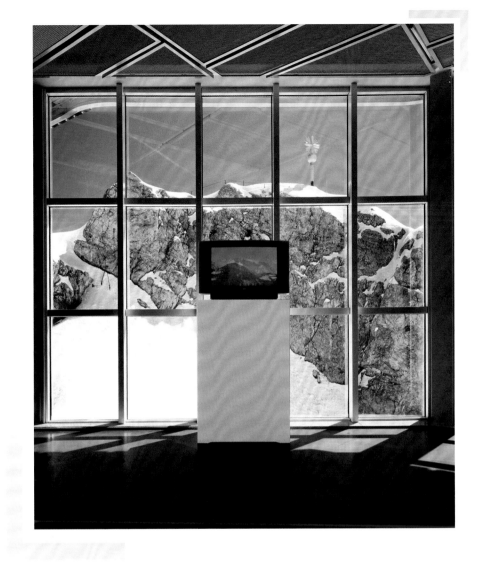

By contrast, or we could also claim it as radicalizing Friedrich's approach, Jeff Wall's *Blind Window* series (2000; pp. 35, 36, 85) examines the window as an object that denies sight altogether. In these works, Wall departs from the standard two-dimensional appearance of photography: the photographs are printed as transparencies and displayed in backlit light boxes, not only simulating a greater degree of three-dimensional illusion, but also resembling filmic screens. Wall's light boxes thus expand the medium of photography into a form in which artworks hover in-between photographic reproductions and projections of light rays. The *Blind Window* images depict dysfunctional windows and as such—dis-

MARCEL ODENBACH
Das große Fenster (The Big Window),
installation view, 2001

67

played within generic interior spaces—deny sight. Not unlike Friedrich, yet much more pronounced, is the way in which Wall engages us through decisive geometrical compositions with dominating diagonals that visually first invite us into the space of the interior until vertical and horizontal wooden planks refute any further exploration of a structure that is dilapidated and dead. With these photographs, Wall recalls modernist abstract art in a constructivist dress, as, for example, articulated in photographs by Alexander Rodchenko. Wall's light boxes display not only ordinary objects but also deteriorated ones that are beautified. Instead of highlighting the decayed character of the sites—most likely the walls of abandoned buildings, no longer habitable, whose windows have been barricaded with wooden planks—Wall transforms rotten objects into strongly aestheticized, colorful surfaces with an alluring contrast of various materialities: the shining, almost metallic-looking surfaces of the walls and the fresh, colorful appearance of the wooden planks. Immersed into this atmosphere of mystery, the viewer stumbles over the large-scale wooden boards that literally and metaphorically eradicate windows as sites of seeing; many of the planks take on the shape of windows themselves, while others take on the shape of window frames that likewise deny sight. Wall in these ways thematizes windows as opaque frames. Considered in tandem with the beautiful geometric and abstract composition, these windows abandon life and being, quite similar to how those who once inhabited the interiors vacated the uninhabitable spaces. Not that different from Friedrich's painting, which contemplates the act of seeing as one that has already been framed and thus hinders an active perceptual process, Wall's objects too make us wonder about how far windows ever invite an engagement between us and the world. The ones presented here doubtless buttress a notion of the window as a perceptual barrier, a frozen non-place that denies interaction and being. Wall, of course, does not accidentally visualize connections between non-seeing and uninhabitable spaces. His images not only allude to the desirability of an embodied experience, but also convey—especially considering their constructivist-inflected composition and, by extension, leftist agenda—the extent to which Wall here pushes into the realm of a socially and politically reflexive aesthetic practice. In light of Wall's dystopian windows, Friedrich's aspiration for an embodied subjectivity remains truly embedded in the sphere of Romantic idealism.

Olafur Eliasson's installation *Seeing Yourself Seeing* (2001; p. 60), however, adds a more positive twist to artistic representations of windows. The installation consists of a large-scale window pane that is surprisingly disconnected from an architectural wall and is instead installed within an exhibition space as a free-floating mobile suspended from the ceiling. It invites spectators to connect the space in front of the window with that behind it. Yet Eliasson complicated this simple act of looking through a window by applying vertical strips of mirror tape to one side of the glass panel, which not only impedes a

translucent viewing experience but also enables us to see reflections of ourselves within the space behind us, both of which we cannot access in any way other than through sight. Lastly, the view through the glass panel opens up into a space that we can see yet also not inhabit, replicating the common window experience, or so it seems at first. On the other side of the installation, we encounter how a window divided into translucent and opaque vertical stripes distorts a unified viewing experience. Eliasson's window directs all of our efforts toward framing sights to fragmentations—of ourselves, the space in front of us, and the one behind. As viewing subjects, we have control neither over our own image nor over the spaces the window creates.

Once we leave our stable and static viewing position in front of the window and move to the sides, Eliasson, engages us in multiple acts of framing and reframing sight. Walking along the window pane enables us to test a broad range of viewing locations that always implicate us, yet always in different ways, into the gallery space to create ever new and unpredictable connections between us and our immediate environment. Eliasson's window transforms into an interface that permits us to vacillate between seeing and moving, and between perceiving and encountering ourselves in relation to the actual space of the gallery. What we never lose, while engaging with Eliasson's object, is a distinct connectivity between our own reflections, views through the window, and the actual gallery space. Considering the fragmented nature of sight and reflections, and the contingent and short-lived encounters of our moves, we experience seeing and bodily encounters as unstable and open modes of perception. We are always aware of ourselves interpenetrating the world, while also recognizing it as a sphere outside of us. With this installation, Eliasson transgresses the common window as a site of disembodied, isolated, and homogenous views. Instead, interacting with this installation means to experience encounters and perceptions that involve both seeing and corporeal movement, creating a multiplicity of relational experiences between us, other viewers, and the spaces we inhabit.

[WATCHING SCREENS]

Doug Aitken's photograph *screens* (2005; p. 70) depicts a blurred view of various windows that shape the façade of a modernist yet indistinct apartment building. Rather than enhancing sight, the image challenges perception, especially windows as a visual promise of translucency. A human hand intrudes diagonally across the foreground of the photograph, holding up a little plastic bag that comes into sight as a small, blurry screen preventing visibility. As a means of focusing the spectator's attention, the plastic bag is positioned in the center of the photograph; it performs as a stand-in for the windows of the apartment building in the back of the image, which likewise look more like white

DOUG AITKEN
screens, 2005

70

screens onto which images may be projected than windows proper. The only focused objects in the photograph are the dark, silhouetted arm and hand.

Considering the diffuse representation of windows in this artwork, it is not farfetched to comprehend Aitken's photograph as transforming windows as sites of sight into screens that require light projections to produce images. Similar to Wall's light boxes, the windows in Aitken's photographs, rather than constituting sight, are dysfunctional. According to Aitken, then, screens are not virtual substitutes for windows, as Anne Friedberg suggests.[12] Instead, they establish a different register of seeing and perception, one based on electronic rays of light that are subject to constant processes of change and alteration that bring about new forms of perceptions, unstable and unfixed, and, rather than playing to the contemplative gaze, ask for distracted forms of attention.[13] Aitken alludes to the different order of screens through the very blurriness he employs in this photograph. It encompasses, we can argue, both an activation of space and a spatialization of time. German art historian Erwin Panofsky argued in his essay "On Movies" that both combined together result in complex, heterogeneous, and fractured representations that are inherent qualities of moving images.[14] Blurriness, as visualized by Aitken, brings about an image whose deviation from its referent not only bears allusions to the immateriality of the computer screen image but also, and maybe more importantly, endows screen images with an aesthetics of movement and thus with unfixed and open-ended possibilities of perception. Also relevant, in this context, is Paul Virilio's characterization of the screen as a temporal window that foregrounds imagery as virtual, fleeting, and dematerialized.[15]

Artistic interpretations of screens negotiate these time-based perceptions and affective engagements with the window turned screen, the static image turned mobile. Maybe surprisingly, I would like to also consider Alfred Stieglitz's photograph *Sun Rays, Paula, Berlin* (1889; p. 72) in this context. In this early photographic example, the light rays projecting into the bourgeois interior convert harmless spectators into curious and intruding voyeurs keen to decipher personal items of "Paula" while watching her write. It is not the window itself that provides visibility to otherwise concealed spaces, perforating the strict divide between public and private spaces, but the screening of light rays, which actually let us wander with our eyes and bodies around in the space, distinguishing between dark and lit spaces in order to observe as much as we can see. This form of voyeuristic watching is turned upon its head in Valie Export's video documentation *Touch Cinema* (1968; p. 73), which transforms voyeurism into a thoroughly affective experience.

12. Friedberg, *Virtual Window*, 21.

13. See Walter Benjamin, "The Work of Art in the Age of Mechanical Reproduction," in *Illuminations: Essays and Reflections*, ed. Hanna Arendt, trans. Harry Zohn (New York: Schocken, 1969), 234, 236.

14. Erwin Panofsky, "On Movies," *Bulletin of the Department of Art and Archaeology of Princeton University* (June 1936). For a more recent reprint, see *Film Theory and Criticism*, 4th edition, ed. Gerald Mast, Marshall Cohen, and Leo Braudy (New York: Oxford University Press, 1992).

15. See Anne Friedberg, "Virilio's Screen: The Work of Metaphor in the Age of Technological Convergence," *Journal of Visual Culture 3*, no. 2 (2004): 183–93, http://dblab.usc.edu/Users/csci599/Friedberg04.pdf.

Fig. 7.
ALFRED STIEGLITZ
Sun Rays, Paula, Berlin,
1889

VALIE EXPORT
Still from *Touch Cinema*, 1968

In this short documentary film, we see the artist Valie Export wearing a simplistic cardboard simulation of a TV with a screenlike front with two small openings. These openings serve the practical purpose of accommodating a participant's hands and arms, yet they also replicate flatness and depth, both qualities of televisual illusion. The boxlike frame covers the artist's naked chest. The filmed performance was staged several times, including in 1968, when male passersby on Munich's Stachus square were invited to enter the "cinema"—the cardboard box—with their hands in order to touch the artist's bare chest. Export's intention was to demonstrate that "the tactile reception is the opposite of the deceit of voyeurism."[16] Through this provocative performance, Export adopted an embodied spectatorship, one that in this case is bound to theatrical encounters. Artistic subject—Export herself—and viewing object—the male passerby—meet through touch and play rather than fixed, static representations. Export's body functions as a screen, with the screen blocking vision in order to stress another form of encounter, that of touch. This early form of experiential aesthetics, which resulted in a video documentation rather than in a permanent work of art, transgressed the bourgeois voyeurism that Stieglitz's photograph depicts.[17]

Disengaged looking and seeing, as well as previously framed sights, are replaced by touch, restricted, however, to the short time span of thirty seconds, as if the relational encounter between Export and her male participant would duplicate the short-lived, time-based

16. Export further explicated the political nature of this artwork. *Touch Cinema*, she wrote, "is an example of activating the audience as reinterpretation of the screen. Tactile instead of visual communication. A new organization of filmic elements necessitates new communication and, along with it, new experience. Sociological models, as reinforced in movies, are thus broken down. New sociological models, new modes of human behavior emerge, such as the socialization of sexuality. Stop private ownership of eroticism, socialize sexuality." Valie Export, "Text about *Tap and Touch Cinema*," http://www.thegalleriesat-moore.org/publications/valie/valietour3.shtml#valietext.

17. Michel de Certeau made a distinction between the flaneur who perceives from above, employing the example of the view from the world trade center into the streets of New York City, and the bodily perception of those same streets from within (or below). While the flaneur, adopting the view of "god," does not actively engage with space, the dweller in the streets does, as he uses space and transforms it into place through momentary constellations he experiences. See de Certeau, "Kunst des Handelns," in *Praktiken im Raum (1980)* (Berlin: Merve, 1988), 177–238.

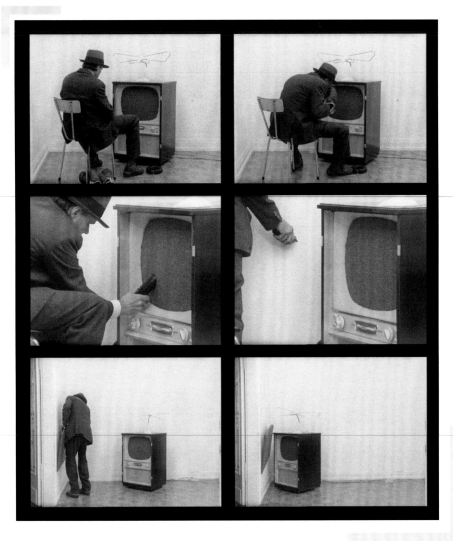

forms of perception characteristic of television and cinema.[18] Export's performance of course sought to challenge bourgeois sexual taboos, which she contested by turning the former passive spectator into an actor and participant. The TV screen, which promises endless yet passive immersion and places us concurrently comfortably in our homes and somewhere else in the world,[19] all of a sudden here transforms us into actors ourselves. Instead of comfortably consuming fluctuating images, which in this case would consist of nude female bodies, male performers on Munich's Stachus square display both pleasure and

18. See http://www.medienkunstnetz.de/works/tapp-und-tastkino/video/1/.

19. See Branden W. Joseph's discussion of televisual perception as dominated by a split or fissured reception in his *Random Order: Robert Rauschenberg and the Neo-Avant-Garde* (Cambridge, MA: MIT Press, 2003), 121–207.

JOSEPH BEUYS
Stills from *Filz TV (Felt TV)*, 1970

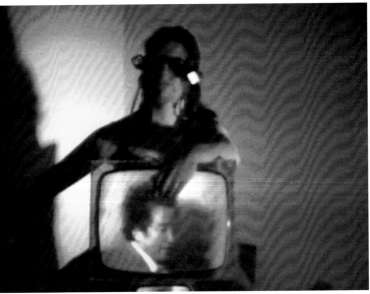

CHARLOTTE MOORMAN
AND NAM JUNE PAIK
WITH JUD YALKUT
Still from *TV Cello
Premiere*, 1971

discomfort while publicly touching a woman's breasts. This artwork is neither produced nor can be consumed as a commodity. Export clearly distinguishes between representation and reality and conceives of a spectatorial reception that reterritorializes the spectator. Dislocated from a habitual, reified, and uniform mode of gazing at a TV screen, the male participant encounters his senses in a very tangible manner.

With Export's work, watching an electronic screen turns into an experiment where subject and object, toucher and touched, relate to each other through bodily contact. What we, the spectators of the video documentation, see are embodied subjects who, however, experience themselves as quite different from each other. Export experiments with what we could call a lived engagement that illuminates a multiplicity of subjectivities performing sensual encounters in a specific spatiotemporal situation. Yet these encounters are also located within the socially constructed context of challenging sexual conventions of the 1960s, so self-presence is complemented here by a critical distance that is reflexive of these social conventions.

Other uses of the TV and the body as interfaces to simultaneously experience and perceive the world include Joseph Beuys's 1970 *Filz TV* (*Felt TV*) and Charlotte Moorman and Nam June Paik's *TV Cello Premiere* (1971), the latter a short video in which Moorman performs on a video cello object created by Paik.

In *Filz TV*, we watch Joseph Beuys interacting with a television, the only performance by Beuys that was ever recorded for and screened on television. It was made for Gary Schum's TV gallery and Schum's *Identifications* project, which was broadcast on German television. In this short piece, Beuys interacts with a screen that is covered by a piece of felt, one of the materials that the artist favored and frequently used. In the beginning, we see him remove a corner of the felt to get a glimpse of the TV picture—which is dysfunctional. In the remainder of the piece, we see Beuys, from behind, watching the felt-covered screen while listening to somewhat uninspiring news reports on economics, politics, and the expansion of German TV coverage. After a short while, Beuys ignores the reportage and begins to act: he boxes himself, pretends to hit the screen, uses a piece of blood sausage to "paint" the

BILL VIOLA
Stills from *Reverse Television
—Portraits of Viewers*, 1983

76

WINDOW | INTERFACE

felt-covered screen, cuts the sausage, creates an installation with an additional piece of felt and the TV set, and finally exits the stage, leaving the viewer with some minutes left to listen to the TV coverage and look at the new minimalist installation.

As much as Beuys himself is unable to see anything on the television screen, so too are we prevented from seeing the artist in a frontal position. He never faces the camera. Unlike Bill Viola's 1983 video project *Reverse Television–Portraits of Viewers*, which was filmed from the visual perspective of the television set itself, in Beuys's piece sight is displaced by an artist who instead plays in front of and with a television. His materials, derived from organic animal sources, are in contrast to the malfunctioning electronic device that is transformed, over the course of the video, into a Beuysian object. Similar to Meret Oppenheim's fur-lined teacup (1936), the television in Beuys's video appears as an alienated and mysterious object, like a readymade, taken out of its usual context in order

Fig. 8.
MERET OPPENHEIM
Object, 1936

to gain significance as an art object. The TV object is transformed through the creative intervention of an artist and made part of an installation through which we are invited to virtually move in order to establish contingent relationships that frame and reframe what we experience and see. Although we never see what happens on the screen, we neverthe-less are fully grounded in the social context of a televisual culture. We can comprehend Beuys's video as a critique of television, as he exchanges the passive act of watching with an active, even creative interaction. At the same time, we can also read the video as an interrogation into the nature of seeing. What we, the viewers of the video, experience is an artwork in process rather than a finalized, already fixed, and permanent object. Moreover, in this video Beuys foregrounds the inability to see: he can't see what is happening on the screen, and we can't see the artist, or rather, we can't see him seeing—we see his body movement and watch him doing something, but as it is never entirely clear what he does or, maybe more importantly, why he does it, we begin to let our imaginations play in order to freely associate his performance and the objects with which he engages. It is this relation between seeing and interacting that invites reflection on the new order of engagement, the third space that entails both sight and abstracted contemplation, as well as corporeal experimentation. It is through the latter that Beuys implicates lived time and space.

Both Beuys and Export alter the screen in order to use it as an interface for bodily interac-tion and embodied sensory experiences. Whereas both artists thematize and privilege corporeal experiences over abstract sight, Charlotte Moorman's performance on Nam June Paik's video cello object appears, from a spectator's perspective, to favor seeing over hearing. *TV Cello Premiere* is the first document to record Moorman's performance on this legendary video cello. Together, Moorman and Paik refocus and expand the possibilities offered by electronic media in order to enhance and exchange various sensory experi-ences at once. The viewer of Moorman's performance is first and foremost puzzled by the inability to hear any music: at play here, like with Beuys and Export, is an aesthetic strategy that displaces and replaces sensory experiences.

The elaborate video sculptural object that Paik created consists of three translucent TV monitors stacked together with vertical strings attached to the full length of the front, simulating the shape of an "electronic" cello. While Moorman "plays" the cello, we observe a montage on the three screens of deformed, prerecorded images of Janis Joplin and Nam June Paik at the piano and Charlotte Moorman playing the TV cello. This montage of moving images is only to a certain extent related to Moorman's performance. Images of Joplin and Paik playing the piano connect to the greater theme of musical performances but are unrelated to the actual play of Moorman, who is a classical cellist. Her stroking of the strings produces not sound but images on the screens, a broadcast experience set in

simultaneously different temporal and spatial orders. Paik and Moorman's strategy recalls avant-garde practices that undermine unified and homogenous perceptual experiences through practices of montage.[20] Defying narrative or logical order, the artists replicate the same activity—musicians playing instruments—on three screens, while at the same time engaging a life event, the performance of Moorman. The work divides our attention between watching the screens, which comprise an integral part of the cello object, and observing a performance, switching our interest between whole and independent parts. We are at once situated in different situations: Moorman's performance transports us into a public theater, where we collectively engage in an aesthetic experience, while the TV screens move us back into the passive role of viewer watching what the televisual screen has to offer. Similar to Export and Beuys, Paik and Moorman complicate the activity of seeing by interpenetrating it with more bodily aesthetic experiences, the lived-through-ness of performance art. While Export and Beuys do so by abstaining from employing functioning technology at all, *TV Cello Premiere*, by contrast, thoroughly relies on it in order to highlight screen culture as one that ruptures the contemplative and static gaze.

[EXPANDING THE SENSORIUM]

Umberto Boccioni's seminal painting *The Street Enters the House* (1911; p. 80) visualizes within the static medium of painting simultaneous rather than successive movement as well as a cacophony of other sensory attractions, such as noise and smell, delivered through the depiction of a street scene in commotion. These sensations penetrate through a window into an interior space, breaking down the notion of the window as separating private and public, interior and exterior. One year later, in 1912, Boccioni demanded in the "Technical Manifesto of Futurist Sculpture": "Let's split open our figures and place the environment inside them."[21] His crucial 1912 painting, *Materia,* depicting his mother sitting in front of an open window, visualizes this concept of a rambling and jumbled outside world breaking into the interior and, more specifically, penetrating his mother's body.[22] In contrast to the common iconography of window paintings that show somebody looking, in this case it is the mother's body, divided into a multitude of Cubist fragments, that is placed in front of an open window so as to interface with the sensory impulses the world beyond the window offers. Clearly Boccioni created a painting not about abstracted vision but about a bodily encounter with a modernity in constant motion, preventing static and frozen images. Consequently, the painting thematizes rhythmic intensity in order to illuminate a kinesthetic encounter with spaces filled with motion, smell, and noise. Importantly, at the same time, Boccioni catapults us, the spectators, into the center of the image, where we experience our own immersion with a multitude of sensory impulses. Thus, with this and similar works, Boccioni does away with the Cartesian separation of observer and aesthetic

20. In a different performance, Moorman played Paik's electronic cello in the nude, a gesture obviously underscoring avant-garde strategies of shock used to challenge bourgeois taboos, yet also contributing to artistic efforts to highlight bodily encounters.

21. Umberto Boccioni, "Technical Manifesto of Futurist Sculpture" (1912), in *Futurist Manifestos*, ed. Umbro Apollonio (London: Thames and Hudson, 1973), 63.

22. The title of the painting is, of course, a reference to Henri Bergson's influential 1896 book, *Memory and Matter* (London: G. Allen & Co., Ltd.; New York: Macmillan, 1929), which was widely read by the Italian Futurists.

UMBEᴦTO BOᴄᴄIONI
The Street Enters the House, 1911

Fig. 10.
MARC CHAGALL
Paris Through the Window,
1913

object, the divide between body and mind, the division between interior and exterior, and between seeing and experiencing. The windows in his paintings metaphorically collapse, much as his paintings as windows do. With Paul Virilio, we already may distinguish them as modern screens, since the surfaces of these paintings as well as what is depicted on them are fractured into a multiplicity of windows. Rather than providing stable and homogenous perceptions of the world, Boccioni's windows demonstrate the extent to which the bustling and dynamic spaces of modern urbanity have become part and parcel of the space on the near side of the windows. They ask for affective bodies, as vision alone is an insufficient tool to relate to the sensations of modernity. Instead, we experience modern life through the phenomenal body itself, and the acclaimed superiority of vision gives way to other sensory registers such as touch, hearing, and smell.[23]

Similar, yet more modest in its aesthetic language, is Marc Chagall's painting *Paris Through the Window* (1913). It likewise illuminates a modernity that cannot be perceived through vision alone. Chagall underscores the breakdown of the window as a means to enabling

23. See Hansen's discussion of the phenomenal body in relation to Maurice Merleau-Ponty in his *Bodies in Code: Interfaces with Digital Media* (New York: Routledge, 2006), esp. 21, 51, 122.

81

and controlling sight through the doubling of a viewer's face—a viewer who stares in two directions simultaneously yet is still incapable of framing a coherent view of the surrounding city. In contrast to the voyeur at work in Stieglitz's photograph, who engages in a distanced viewing act with a disembodied gaze, the perceptual experience in Chagall's painting is of a disorienting nature. Both the viewer of the painting and the painted window viewer are immersed into the fantastic spaces of Paris, whereby the presence of their selves becomes part of the spectacle of the modern city.

Modernists such as Boccioni represented such multisensorial encounters within and through a revision of the static medium of painting as they liberated the canvas from its task of providing an imitative and illusionary representation of experiential reality. In the end, however, they could not help but objectify embodied perception through static depictions. Nevertheless, these paintings speak to the need for new conceptualizations of perception and aesthetic experience, ones that would modify the fixed relation between subject and object in order to convert it into an open-ended process in which both performing spectator and aesthetic object encounter each other through a multitude of new significations.

Today, many contemporary artists are first and foremost concerned with responding to an increased expansion and disintegration of art forms in the twentieth and twenty-first centuries, as set in motion by artists such as Boccioni nearly a century earlier, as well as the all-encompassing technological screen culture. They employ at once screens that project images in motion as well as elements of installation art that entail embodied, kinesthetic encounters. While we may argue that these screens set the imaginary in motion in order to frame and reframe, constitute and reconstitute, images that lack visual stability and fixity, the installation itself turns our bodies into spatial organizers.[24] According to Juliane Rebentisch's examination of installation art, it is the double structure of art that is thematized in instances that take on the form of spatial ensembles. On one hand, we perceive the aesthetic object as an experiential entity in itself, while on the other, we encounter ourselves as performing spectators, utilizing all of our sensory capacities to constitute the artwork over and over again.[25]

The concern with multisensory encounters that thematize tactile experiences and kinesthetic sensation, while concurrently exploring the significance and qualities of seeing and vision, is centrally explored in multimedia works by Doug Aitken. As we have seen, his 2005 photograph *screens* imbues the static view through the window with perceptual registers that focus attention on embodied sensations and unstable, blurry visualities.[26] His multimedia work *new skin* (2002) consists of an installation that employs two large-scale interlocking elliptical screens that are in the shape of eyes, suspended from the gallery

24. Ibid.
25. See Juliane Rebentisch, *Ästhetik der Installation* (Frankfurt am Main: Suhrkamp, 2003), 55, 56.
26. According to Hans Jonas, it is necessarily the moving body that encounters the world through touch, smell, and hearing—it is self-movement that enables sensory registers beyond vision. See Hansen, *Bodies in Code*, 122, 123.

82

ceiling. Aitken projects his video onto all eight surfaces of the split screens, inviting the visitor to walk through and around the darkened installation, never allowing them to see all images at once. This fracturing of images and concentration on seeing, as well as the experience of being unable to frame or control sight, finds its correspondence in the narrative of the video, which tells the story of a young Japanese girl who goes blind. Aware of her pending fate, she attempts to store as many images as possible in her memory so as to build a mental visual archive or catalogue. In some passages, we see repetitions of images that obviously have already been transformed into the envisioned state of mental memories. Overall, the video asks us to scrutinize the split between body and mind, experience and sight, encountering and perceiving the world, so as to delve into the difference between being and being perceived.[27] However, the realms of body movement—the kinesthetic performance of the girl and the spectator of the installation—on one hand, and the abstract sensory register of seeing, on the other, are presented in *new skin* not as oppositional pairs but as a relation of indeterminacy, as alluded to in the title of the installation.

Fig. 11.
DOUG AITKEN
new skin, installation
view, 2002

27. For more on this topic, see Friedberg's discussion in relation to Henri Bergson in *Virtual Window*, 145.

83

This is made obvious through the physical character of the video installation itself: the projections are interspersed with the material entity of the installation, which occupies an enormous space in the gallery. The spectator vacillates between experiences of unpredictable bodily encounters, enhanced by the darkened space, and distracted perceptions of the video. The action in the video likewise revolves around a figure who experiences public surroundings (through movement and interchange with people and things) while also being tied to a solitary interior, which serves as background space for her endeavor to memorize images. We observe the girl as she engages with unframed sight through her body movement, with fleeting images through the movement of a camera, and lastly with memory as the moving images suddenly and repeatedly freeze into a frame.

Aitken's video demonstrates multiple instances of sensory encounters that the narrative of the video pictures, yet that are also inherent to the form of the video and the installation itself. It consists of sequential images that produce linear and narrative understandings of time and space, precisely framed within the parameters of each screen. Other parts of the video, however, depart from the confines of the screen as frame and occupy, for example, two full or partial screens at once, rupturing the notion of sequentiality in order to coimplicate virtual and real space and time. And, finally, we also see captured screen shots, appearing as rectangular photographs, on parts of the oval screens. Aitken thus demonstrates here the mechanics of various forms of perception and experiential encounters at once: the viewer of the video and the young girl in the video both experience considerable variances in speed, space, and perspective; and the video space and the real space both demand at times disparate and at other times simultaneous modes of attention. These complex and interwoven forms of relating to the world through performance and abstract sight illuminate multiple meanings of object and subject that constantly change and evolve. It is a reality that is unfixed and involved in a continuous process of becoming that Aitken foregrounds here. He also highlights how visual perception and the world of framed sights are always already mediated and constructed, and how they continue to exist despite or in addition to other more open-ended experiential relations between aesthetic object and subject. It is in the latter form, in which the spectator encounters herself as a performing subject, that neither stable sights nor fixed meanings can be constituted by either the object or the subject. What instead happens when spectator and artwork encounter each other is a relational occurrence that involves all sensory registers at once.

Windows and screens in the artworks discussed in this essay are engaged as tools in order to foreground the limitations of pure vision. As such, they demonstrate the insufficiency of relating to the world through framed and fixed images alone, through mechanisms that provide static and stable surfaces from which to contemplate ourselves. Instead,

84

JEFF WALL
Blind Window No. 3,
2000–6

these windows are often transmuted into interfaces that facilitate embodied encounters, as in Beuys's interaction with a felt-covered television screen, or Export's cardboard screen simulation, operating as a tool for bodily interaction and challenging tactile and haptic sensibilities. These screens, while they still structure borders, assist us in traversing boundaries between the seen and performed, acted roles and identities, reality and virtuality, and life and mechanical prostheses.

It is appropriate, then, that the window as an apparatus for controlling sight is heavily scrutinized by contemporary artists. In Jeff Wall's *Blind Windows*, they emerge as places of abstract beauty and, consequently, as sites of non-sight. Marcel Odenbach illuminates the window as a single pane, a multiple grid, and, not least, a semitranslucent curtain in order to reveal the constructedness of images and their role within ideological systems.

Most complex is the coarticulation of seeing and feeling, vision and bodily sensations, in those works of installation art that expand and transgress conventional art forms as fixed entities in order to submit space, objects, and moving images into an interfacial relation with our bodies. As can be seen with Aitken's installation, advanced forms of multimedia installations that use multiple projections as well as specifically designed environments accommodate new encounters in-between abstract viewing, embodied spectatorship, and technology. Interpenetrating each other, the viewer and the artwork, the aesthetic subject and object, produce a multiplicity of sensations that hover in-between representation and experimentation, immersion and critical distance, framed sights and experiential encounters, and thus thematize an unfixed relationality between us and our environment.

Through this expansion of the scope of visual perception into realms of multisensorial encounters, these artists and others deliberately rethink what it means to interrelate to and experience the world, not just through sight but through touch, smell, and movement—a conceptual approach, I would like to conclude, that is not just a response to the impact of multiple screens in our daily lives. It is also a reflection of the denigration of single and autonomous art forms in contemporary art—a reflection that illuminates the confines of framed sight.

SE

HE WHO LOOKS IN THROUGH AN OPEN WINDOW NEVER SEES AS MUCH AS HE WHO LOOKS AT A WINDOW THAT IS SHUT. THERE IS NOTHING MORE PROFOUND, MORE MYSTERIOUS, MORE FERTILE, MORE SINISTER, OR MORE DAZZLING THAN A WINDOW, LIGHTED BY A CANDLE. WHAT WE CAN SEE IN THE SUNLIGHT IS ALWAYS LESS INTERESTING THAN WHAT TRANSPIRES BEHIND THE PANES OF A WINDOW. IN THAT DARK OR LUMINOUS HOLE, LIFE LIVES, LIFE DREAMS, LIFE SUFFERS.

ACROSS THE WAVES OF ROOFS, I SEE A WOMAN OF MATURE YEARS, WRINKLED AND POOR, WHO IS ALWAYS BENDING OVER SOMETHING, AND WHO NEVER GOES OUT. FROM HER FACE, FROM HER DRESS, FROM HER GESTURES, OUT OF ALMOST NOTHING, I HAVE MADE UP THE WOMAN'S STORY, OR RATHER HER LEGEND, AND SOMETIMES I SAY IT OVER TO MYSELF, AND WEEP.

IF IT HAD BEEN A POOR OLD MAN, I COULD HAVE MADE UP HIS JUST AS EASILY.

AND I GO TO BED, PROUD OF HAVING LIVED AND SUFFERED IN OTHERS.

PERHAPS YOU WILL SAY TO ME: "ARE YOU SURE THAT IT IS THE TRUE STORY?" WHAT DOES IT MATTER, WHAT DOES ANY REALITY OUTSIDE OF MYSELF MATTER, IF IT HAS HELPED ME TO LIVE, TO FEEL THAT I AM, AND WHAT I AM?

CHARLES BAUDELAIRE

Doug Aitken (American, b. 1968)
screens, 2005
C-print, ed. 1/6, 48 x 60 ½″
Courtesy of the artist and Regen Projects, Los Angeles
Ill. p. 70

windows, 2007
12 C-prints mounted on aluminium, ed. 4/6,
18 ½ x 23″ ea.
Courtesy of the artist and Regen Projects, Los Angeles

Joseph Beuys (German, 1921–1986)
Filz TV (Felt TV), 1970
Black-and-white video with sound, 3 min.
From *40 Years of Video Art in Germany*
© 2007 Artists Rights Society (ARS), New York/
VG Bild-Kunst, Bonn
Ill. p. 74

Peter Campus (American, b. 1937)
Prototype for Interface, 1972
Video installation, dimensions variable
Collection of Pamela and Richard Kramlich
Installation photo from Antiguo Colegio de San
Ildefonso, Mexico City, Mexico, 2003
Image © Peter Campus, courtesy of Leslie Tonkonow
Artworks + Projects, New York
Ill. p. 23

Lost Days, 2006
Digital video on Apple TV HD player, ed. 5,
4:04 min. loop
Courtesy of the artist and Leslie Tonkonow Artworks
+ Projects, New York

Albrecht Dürer (German, 1471–1528)
Man Drawing a Reclining Woman, 1538
In *Underweysung der Messung (Instruction in
Measurement),* 1525, 2nd edition 1538
Woodcut, 2 ⁵⁄₁₆ x 8 ³⁄₈″
Courtesy of the University of Wisconsin, Madison
Ill. p. 25

Olafur Eliasson (Icelandic,
b. Denmark, 1967)
Seeing Yourself Seeing, 2001
Wood, glass, and mirror, 39 x 39″
Collection of Themistocles and Dare Michos,
San Francisco
© 2007 Artists Rights Society (ARS), New York/
COPY-DAN, Copenhagen
Ill. p. 60

Cerith Wyn Evans (Welsh, b. 1958)
Think of this as a Window, 2005
Neon mounted on Plexiglas, 5 ½ x 57 ⁵⁄₁₆ x 2″
Courtesy of Galerie Neu, Berlin, Germany
Ill. pp. 8–9

Valie Export (Austrian, b. 1940)
Touch Cinema, 1968
Black-and-white video with sound, 1:08 min.
Courtesy of Electronic Arts Intermix (EAI), New York
Ill. p. 73

Kirsten Geisler (German, b. 1949)
Dream of Beauty—Touch Me, 1999
Touch screen, DVD player, and DVD, 13 ³⁄₄ x 11 ³⁄₄ x 1 ⁵⁄₈″
Courtesy of Galerie Thomas Schulte, Berlin, Germany
Ill. pp. 27, 28

Gary Hill (American, b. 1951)
Windows, 1978
Color video, 8:28 min.
Courtesy of Electronic Arts Intermix (EAI), New York
Ill. p. 41

David Hilliard (American, b. 1964)
Andreu, 1996
C-print, 3 panels, 40 x 30″ ea.
Courtesy of the artist and the Bernard Toale Gallery,
Boston
Ill. pp. 52–53

Home, Office, Day, Evening, 2006
C-print, 3 panels, 40 x 30″ ea.
Courtesy of the artist and the Bernard Toale Gallery,
Boston
Ill. pp. 54–55

Iñigo Manglano-Ovalle
(American, b. Spain, 1961)
Le Baiser (The Kiss), 1999
Multichannel video installation, dimensions variable
The Museum of Contemporary Art, Chicago, Sara Lee
Corporation Purchase Fund, 1999.56
Ill. p. 38

Charlotte Moorman
(American, 1933–1991)
Nam June Paik
(American, b. Korea, 1932–2006)
Jud Yalkut
(American, b. 1938)
TV Cello Premiere, 1971
Color video, 7:25 min.
Performance by Moorman; video by Paik and Yalkut
Courtesy of Electronic Arts Intermix (EAI), New York
Ill. p. 75

Marcel Odenbach (German, b. 1953)
Das große Fenster (The Big Window),
2001
Color video with sound
Courtesy of Anton Kern Gallery, New York
Ill. p. 67

Jeffrey Shaw (Australian, b. 1944)
The Golden Calf, 1995
Computergraphic installation with computer, pedestal,
LCD monitor, and position sensor, dimensions variable
Courtesy of Luc Courchesne; software by Gideon May
Ill. pp. 32–33

Hiroshi Sugimoto (American, b. Japan,
b. 1948)
Radio City Music Hall, 1977
Gelatin silver print, 16 $\frac{1}{2}$ x 21 $\frac{1}{2}$″
Saint Louis Art Museum, Martin Schweig Memorial
Fund for Photography
Ill. p. 44

Goshen, Indiana, 1980
Gelatin silver print, 20 x 24″
Courtesy of Ann and Steven Ames, New York
Photo courtesy of Sonnabend Gallery
Ill. p. 45

Union City Drive-in, Union City, 1993
Gelatin silver print, 20 x 24″
Collection of Arthur and Susan Fleischer

U. A. Walker, New York, 1978, 2000
Photogravure, 17 x 21 $\frac{1}{2}$″
Courtesy of William Shearburn Gallery, St. Louis
Ill. p. 42

Bill Viola (American, b. 1951)
Reverse Television—Portraits of Viewers
(compilation), 1984
Color video with sound, 15 min., from a 1983 project of
44 portraits broadcast in between television programs
as unannounced inserts, produced by WGBH-TV New
Television Workshop, Boston
Courtesy of Electronic Arts Intermix (EAI), New York
Photo: Kira Perov
Ill. p. 76

Jeff Wall (Canadian, b. 1946)
Blind Window No. 1, 2000
Cibachrome transparency and aluminum light box, ed. 5,
42 $\frac{5}{16}$ x 52 $\frac{5}{16}$″
Courtesy of the artist and Marian Goodman Gallery,
New York
Ill. p. 36

Blind Window No. 2, 2000
Cibachrome transparency and aluminum light box, ed. 5,
52 $\frac{3}{4}$ x 67 $\frac{1}{8}$″
Courtesy of the artist and Marian Goodman Gallery,
New York
Ill. p. 35

Blind Window No. 3, 2000–6
Cibachrome transparency and aluminum light box, ed. 5,
15 $\frac{13}{16}$ x 20″
Courtesy of the artist and Marian Goodman Gallery,
New York
Ill. p. 85

Doug Aitken (American, b. 1968)
new skin, 2002
Video installation with four projections onto
elliptical x-screens, dimensions variable
Broad Art Foundation, Santa Monica
Fig. 11, p. 83

Umberto Boccioni
(Italian, 1882–1916)
The Street Enters the House, 1911
Oil on canvas, 39 x 39"
Sprengel Museum Hannover, Germany
Photo: Michael Herling / Aline Gwose
Fig. 9, p. 80

Marc Chagall
(Belorussian, 1887–1985)
Paris Through the Window, 1913
Oil on canvas, 53 ½ x 55 ¾"
Solomon R. Guggenheim Museum,
New York
Gift, Solomon R. Guggenheim, 1937, 37.438
© 2007 Artists Rights Society (ARS),
New York / ADAGP, Paris
Fig. 10, p. 81

Douglas Engelbart
(American, b. 1925)
A demonstration of the "Mouse"
with Douglas Engelbart, 1968
Still from a videotape of a presentation
at the Fall Joint Computer Conference,
San Francisco, 1968
Courtesy of the Department of Special
Collections and University Archives,
Stanford University Libraries
© Douglas Engelbart and Bootstrap
Alliance
Fig. 3, p. 31

Mike Figgis (English, b. 1948)
Timecode, 2000
Feature film, 97 mins.
Written and directed by Mike Figgis
Produced by Red Mullet Productions
Fig. 6, p. 47

Caspar David Friedrich
(German, 1774–1840)
Woman at the Window, 1822
Oil on canvas, 17 ⅓ x 14 ½"
Nationalgalerie, Staatliche Museen zu
Berlin, Germany
Photo: Joerg P. Anders, Bildarchiv
Preussischer Kulturbesitz / Art Resource,
New York
Fig. 1, p. 14

Ludwig Mies van der Rohe
(German, 1886–1969)
Farnsworth House, 1951
http://www.math.umd.edu/~dng/
WorldCourses/WRLD125/ARCH/
Farnsworth.html
Fig. 5, p. 39

Meret Oppenheim
(Swiss, 1913–1985)
Object, 1936
Fur-covered cup, saucer, and spoon: cup,
4 ⅜" diameter; saucer, 9 ⅜" diameter; spoon,
8" long; overall height 2 ⅞"
The Museum of Modern Art, New York
Digital Image © The Museum of Modern Art /
Licensed by SCALA / Art Resource, New York
© 2007 Artists Rights Society (ARS),
New York / ProLitteris, Zürich
Fig. 8, p. 77

Alfred Stieglitz
(American, 1864–1946)
Sun Rays, Paula, Berlin, 1889
Gelatin silver print, 8 ⅔ x 6 ⅓"
Courtesy George Eastman House, Rochester,
New York
© 2007 Georgia O'Keefe Museum / Artists
Rights Society (ARS), New York
Fig. 7, p. 72

Ivan Sutherland
(American, b. 1938)
Ivan Sutherland using a CAD
program on the TX-2 computer,
1963
Courtesy of the Computer History Museum,
Mountain View, California
Fig. 2, p. 30

Jeff Wall (Canadian, b. 1946)
A view from an apartment,
2004–5
Cibachrome transparency and aluminum
light box, 65 ¾ x 96 ⅛"
Courtesy of Marian Goodman Gallery,
New York
Fig. 4, p. 37

Doug Aitken

Ann and Steven Ames

Anton Kern Gallery, New York

Bernard Toale Gallery, Boston

Peter Campus

Luc Courchesne

Electronic Arts Intermix (EAI), New York

Arthur and Susan Fleischer

Galerie Neu, Berlin

Galerie Thomas Schulte, Berlin

Kirsten Geisler

David Hilliard

Pamela and Richard Kramlich

Leslie Tonkonow Artworks + Projects, New York

Iñigo Manglano-Ovalle

Themistocles and Dare Michos

Museum of Contemporary Art, Chicago

Marcel Odenbach

Regen Projects, Los Angeles

Saint Louis Art Museum

University of Wisconsin, Madison

Jeff Wall

William Shearburn Gallery, St. Louis

Cerith Wyn Evans

FIRST OF ALL, ON THE SURFACE ON WHICH I AM GOING TO PAINT, I DRAW A RECTANGLE OF WHATEVER SIZE I WANT, WHICH I REGARD AS AN OPEN WINDOW THROUGH WHICH THE SUBJECT TO BE PAINTED IS SEEN; AND I DECIDE HOW LARGE I WISH THE HUMAN FIGURES IN THE PAINTING TO BE. I DIVIDE THE HEIGHT OF THIS MAN INTO THREE PARTS, WHICH WILL BE PROPORTIONAL TO THE MEASURE COMMONLY CALLED A BRACCIO; FOR, AS MAY BE SEEN FROM THE RELATIONSHIP OF HIS LIMBS, THREE BRACCIA IS JUST ABOUT THE AVERAGE HEIGHT OF A MAN'S BODY. WITH THIS MEASURE I DIVIDE THE BOTTOM LINE OF MY RECTANGLE INTO AS MANY PARTS AS IT WILL HOLD; AND THIS BOTTOM LINE OF THE RECTANGLE IS FOR ME PROPORTIONAL TO THE NEXT TRANSVERSE EQUIDISTANT QUANTITY SEEN ON THE PAVEMENT. THEN I ESTABLISH A POINT IN THE RECTANGLE WHEREVER I WISH; AND AS IT OCCUPIES THE PLACE WHERE THE CENTRIC RAY STRIKES, I SHALL CALL THIS THE CENTRIC POINT. THE SUITABLE POSITION FOR THIS CENTRIC POINT IS NO HIGHER FROM THE BASE LINE THAN THE HEIGHT OF THE MAN TO BE REPRESENTED IN THE PAINTING, FOR IN THIS WAY BOTH THE VIEWERS AND THE OBJECTS IN THE PAINTING WILL SEEM TO BE ON THE SAME PLANE. HAVING PLACED THE CENTRIC POINT, I DRAW STRAIGHT LINES FROM IT TO EACH OF THE DIVISIONS ON THE BASE LINE. THESE LINES SHOW ME HOW SUCCESSIVE TRANSVERSE QUANTITIES VISUALLY CHANGE TO AN ALMOST INFINITE DISTANCE.

SABINE ECKMANN is director and chief curator at the Mildred Lane Kemper Art Museum at Washington University in St. Louis, where she also teaches in the department of Art History and Archaeology. Among her many publications, she is the curator, editor, and coauthor of *Reality Bites: Making Avant-garde Art in Post-Wall Germany* (Hatje Cantz, 2007), which won the Emily Hall Tremaine exhibition award in 2005; coeditor and coauthor of *Caught by Politics: Hitler Exiles and American Visual Culture* (Palgrave Macmillan, 2007) and *[Grid <> Matrix]* (Mildred Lane Kemper Art Museum, 2006); curator and author of *H. W. Janson and the Legacy of Modern Art* (Salander O'Reilly Galleries, 2002), which was published in German as *Exil und Moderne* (Edition Braus, 2004); and cocurator, coeditor, and coauthor of *Exiles + Emigrés: The Flight of European Artists from Hitler* (H. N. Abrams, 1997), which was awarded best exhibition catalog by the Association of International Critics of Art.

ANNE FRITZ is a Ph.D. candidate in Germanic Languages and Literatures and Comparative Literature at Washington University in St. Louis. She received a DAAD fellowship for the 2007–2008 academic year to conduct research on contemporary photography in preparation for her dissertation on photography, sound, and cartography in the process of placing oneself in the world.

LUTZ KOEPNICK is professor of German and Film & Media Studies at Washington University in St. Louis and curator of new media at the Mildred Lane Kemper Art Museum. He is the author of numerous publications, including *Framing Attention: Windows on Modern German Culture* (Johns Hopkins University Press, 2007), *The Dark Mirror: German Cinema between Hitler and Hollywood* (University of California Press, 2002), and *Walter Benjamin and the Aesthetics of Power* (University of Nebraska Press, 1999); and coeditor and coauthor of *The Cosmopolitan Screen: German Cinema and the Global Imaginary, 1945 to the Present* (University of Michigan Press, 2007), *Caught by Politics: Hitler Exiles and American Visual Culture* (Palgrave Macmillan, 2007), *[Grid <> Matrix]* (Mildred Lane Kemper Art Museum, 2006), and *Sound Matters: Essays on the Acoustics of German Culture* (Berghahn Books, 2004).